IMAGES
of America

BRISTOL

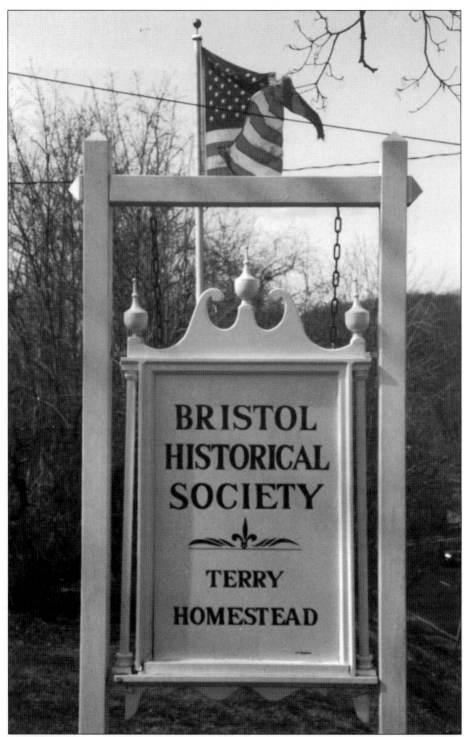

The founding meeting of the Bristol Historical Society was held on April 7, 1971. In 1973, Arthur T. Fletcher, on behalf of the Fletcher family, announced that part of the Terry Homestead, at 54 Middle Street, would be available for the use of the historical society.

IMAGES
of America

BRISTOL

Gail Leach and Steven Vastola

ARCADIA

First printed in 2001.

Published by Arcadia Publishing,
an imprint of Tempus Publishing, Inc.
2A Cumberland Street
Charleston, SC 29401

Printed in Great Britain.

Library of Congress Catalog Card Number: 2001090300

For all general information contact Arcadia Publishing at:
Telephone 843-853-2070
Fax 843-853-0044
E-Mail sales@arcadiapublishing.com

For customer service and orders:
Toll-Free 1-888-313-2665

Visit us on the internet at http://www.arcadiapublishing.com

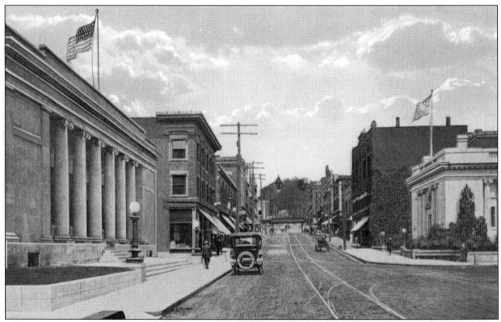

This view of Main Street was taken looking north from the post office before redevelopment. Many of these buildings, including the post office, are now memories of Bristol's past.

CONTENTS

ACKNOWLEDGMENTS

The citizens of 20th-century Bristol saw the tearing down of their core city and felt a deep need to hold on to what they saw disappearing. This need led to the formation of the Bristol Historical Society and, with its archives, the publication of this book. All proceeds from the sale of this book will go to the Bristol Historical Society Building Fund so that a permanent home for the treasures of Bristol's past can be collected and maintained.

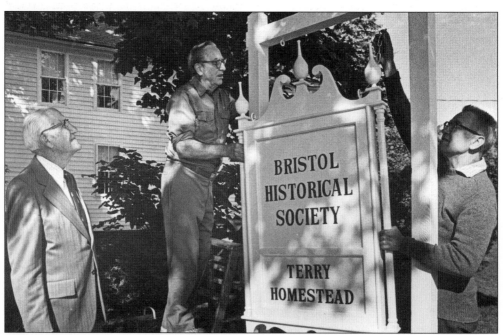

Arthur T. Fletcher (left) supervises Roger C. Manchester and Lawrence Lindblad as they hang the sign of the Bristol Historical Society outside its new headquarters in the former Terry Homestead.

INTRODUCTION

Bristol is an energetic, contemporary city, with a long and noteworthy history. Native American artifacts represent the earliest evidence of human activity in the area. Many artifacts of the Tunxis people have been discovered here. The Tunxis were a peaceful people who hunted in the forested land known as the West Woods and traded goods with other Native Americans, including those from the Hudson River Valley.

Originally, Bristol was within the boundaries of Farmington. In 1721, the area was divided into tiers and lots, which were allotted to the Farmington settlers in the proportions that had been fixed back in 1672. The sons and grandsons of those earliest of Farmington settlers became the proprietors of the land. The first actual settler of what is now Bristol was Daniel Brownson. He built a house near West Street in 1727 but did not remain in the area long. The first permanent settler was Ebenezer Barnes, whose home was built in 1728 at the foot of King Street. In the same year, 1728, Nehemiah Manross from Lebanon bought land and built a house north of the Barnes house, on the west side of King Street. The following year Nathaniel Messenger of Hartford and Benjamin Buck of Southington bought land and built houses along King Street. The first settlement began in what is now referred to as East Bristol.

Other houses were soon built wherever there was land available for farming. Houses were built on the slope of Fall Mountain, which is now Wolcott Street, and on Chippens Hill. In 1742, the families living in the area petitioned the General Court for the right to form their own Congregational society, citing the difficulties of traveling to Farmington during the winter months. The General Court granted their petition for the winter months and two years later agreed that the residents could establish a separate ecclesiastical society and call it New Cambridge. By establishing their own congregation, the settlers began forming a local government. Since the homes were so widely scattered, the General Court assigned a committee to locate the geographic center of the settlement and build a church there. The area now known as Federal Hill was the center, and the first Congregational church was built there.

In 1785, New Cambridge was incorporated as the town of Bristol. In 1790, the industry for which Bristol later became famous was established by the pioneer of clock making, Gideon Roberts. Roberts began making wooden movement clocks in 1790 and peddled them by horseback throughout Connecticut, New York, and Pennsylvania. As his sons grew into the business, Roberts increased his production and, with the help of George Mitchell, the clocks were soon peddled all over the country. All of the capital and skill of the town was soon involved in the clock industry, and many potential clock manufacturers were enticed to come

to Bristol. The clock business gave way to related industries, which included brass, springs, bearings, and hardware and, as Bristol began to thrive and grow, many ethnic groups arrived to work in the industries.

Images of America: Bristol has been created from the photographic resources in the archives of the Bristol Historical Society. Many of the images used in the book were taken for the historical society by Peter Maronn, who displayed great talent and foresight in photographing the town's historical landmarks. The Bristol Jaycees also deserve credit for contributing to the formation of the Bristol Historical Society. This book is dedicated to all the members of the historical society who, over the last 30 years, have worked diligently to collect remembrances of Bristol's past to preserve them for future generations.

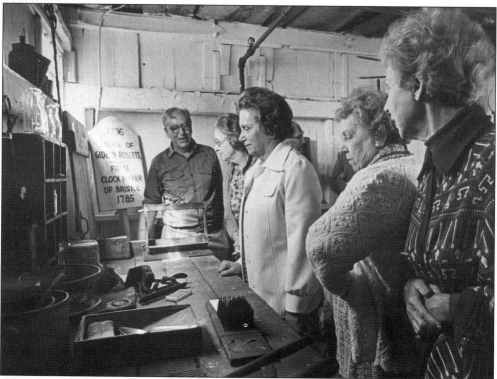

Roger C. Manchester explains a display of early tools and artifacts to (from left to right) Mrs. A. Sessions Wells, Mrs. Frank Jerman, Mrs. M. Richard Anduse, and Dorothy Manchester in the barn annex at the Terry Homestead.

One

BRISTOL'S FIRST
SETTLEMENT

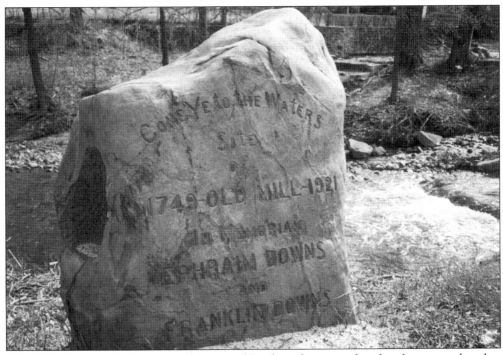

On the corner of Downs Street and Memorial Boulevard is an earth-colored stone marker that represents the very first roots of settlement in Bristol. Langton Mill existed on the pond in the area perhaps as early as 1723. As the settlers from Farmington moved westward in search of arable land, they established the small industries necessary for life in the new community, which at the time was called simply the West Woods. The remains of the mill were torn down in 1921.

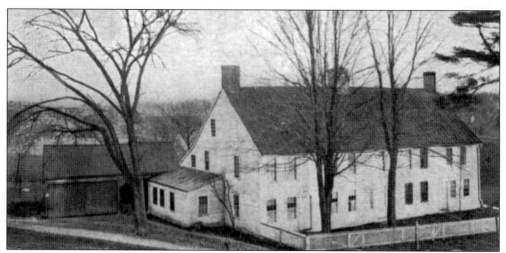

Bristol's first permanent settler, Ebenezer Barnes, built this house in 1728 on land originally allotted to his father, Thomas Barnes. It was located on the King's Highway (now King Street) and served as a tavern for people traveling between Farmington and Waterbury. In early days taverns were public institutions that supplied liquor and newspapers and that served as hotels, eating places, and meeting places. Bristol soon had more taverns than any other Connecticut town, the number exceeding 10 such establishments in the early 19th century. The Pierce family bought the Barnes house in 1795 and continued the tavern business.

The oldest house in Bristol is located at 14 Daniel Road. Benjamin Buck, who came from Southington, built it in 1729. The chestnut-framed Colonial house was thought to have been destroyed but, in 1951, it was discovered hidden by the overgrowth of trees and brush by the Woodland Realty Company.

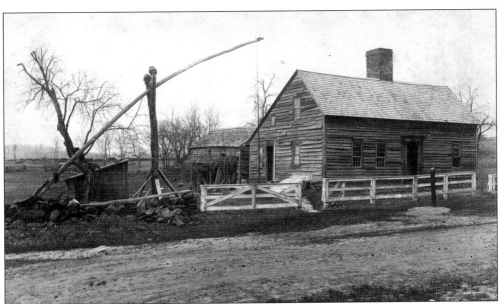

Religion was an important part of the lives of Colonial New Englanders, and attendance at Sunday service was an obligation. However, because of distance, it was difficult for these homesteaders to attend services in the Farmington parish. In 1744, William Jerome signed a petition requesting permission from the Connecticut General Court to create a separate parish. The homestead of Lot Jerome, a descendant of William Jerome, stood on the west side of Stafford Avenue between Brook Street and Douglas Road.

In 1744, the Connecticut General Court granted the petition for a separate ecclesiastical society and called it New Cambridge. By establishing their own congregation, the settlers began forming a local government. Since the homes were so widely scattered, the General Court assigned a committee to locate the geographic center of the settlement and build a church. The area called Indian Quarry Hill, now known as Federal Hill, was determined to be the center, and the first Congregational church was built there. This sketch shows how the second meetinghouse looked at the location, which, today, is occupied by the third meetinghouse.

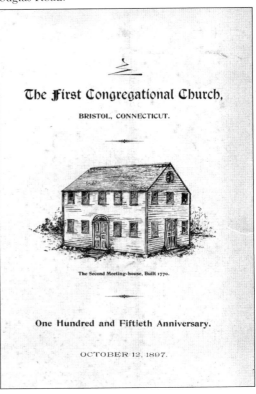

The First Congregational Church,

BRISTOL, CONNECTICUT.

The Second Meeting-house, Built 1770.

One Hundred and Fiftieth Anniversary.

OCTOBER 12, 1897.

Here Lyeth Interred the Body
of y. Rev. Samuel Newell. A.M.
late pastor of the Church of
Christ in New Cambridge.
A Gentleman of Good Genius,
Solid Judgment found in the faith,
A fervent, and experimental
Preacher of unaffected Piety:
Kindest of Husbands. Tenderest of
Fathers, the best of Friends, and an
Ornament of the Ministry.—
And having served his generation
faithfully by the will of God,
with serenity & Calmness he fell
on sleep, February y. 10th. 1789
in the 75th. year of his Age.
And the 42. of his Mineftry.

Death; Great Proprietor of all; 'tis thine,
To tread our Empires, and to quench y. ftar.

In 1747, Samuel Newell became the first minister of the fledgling Congregational parish. Born in 1714, he graduated from Yale College in 1739 and preached in East Hartford until he was proposed as pastor to the New Cambridge Society. Parson Newell carried on his ministry until 1783, when he was struck by paralysis. He recovered and continued to perform some part of his duties until his death in 1789. His grave marker, located in the Downs Cemetery, describes him by character and deed.

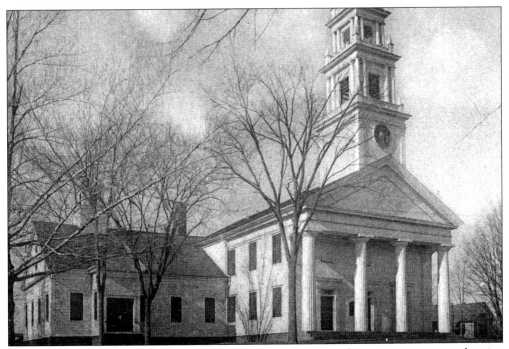

The Congregational church also served as a meetinghouse and community center, drawing together people from the outlying farm areas. By 1742, the Great Awakening had arrived in Connecticut and caused serious divisions in the community of New Cambridge. The choice of Samuel Newell as minister was by no means unanimous.

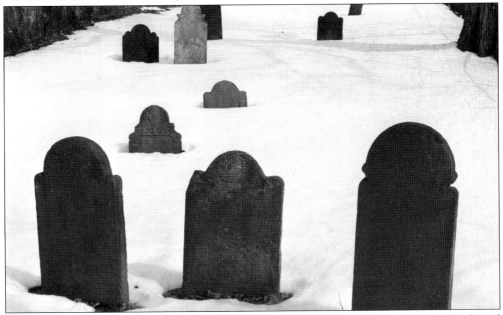

The dissenters, who made up a small minority, withdrew from the Congregational church and formed a separate society affiliated with the Church of England. They built a small meetinghouse on Federal Hill, establishing their parish. Their cemetery is all that remains on that site.

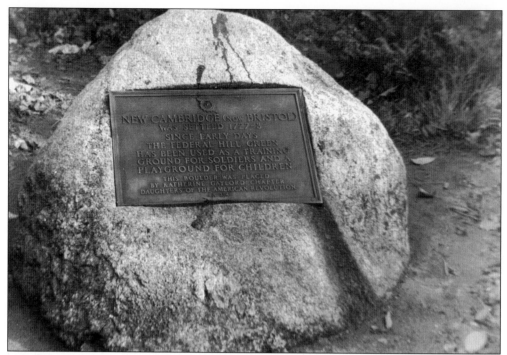

The Federal Hill Green was first used as a common pasture and training ground. In 1773, it was also used as a place of parade where the militia trained during the Revolutionary War.

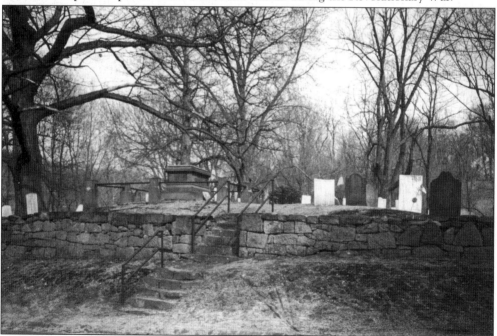

The Old South Cemetery, or the Downs Cemetery, as it is better known, is the oldest burial ground in Bristol. The graves of 23 Revolutionary War soldiers from Bristol can be found in this cemetery, along with other notable settlers, including Abigail Demming, Winston Churchill's forbearer.

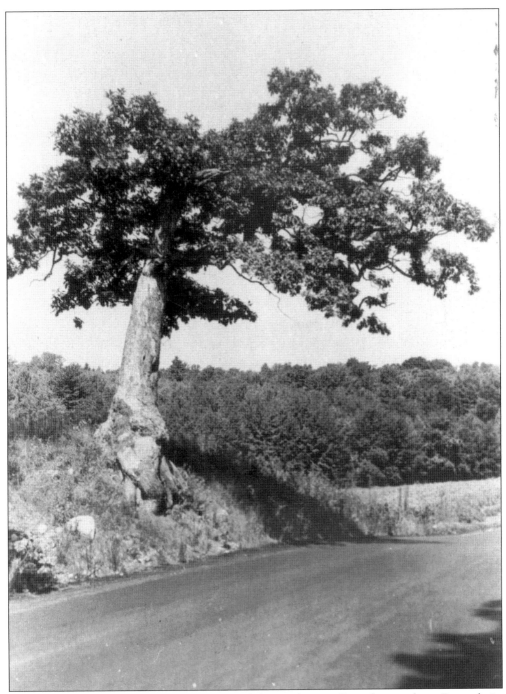

The Peaceable Oak is located just south of the Burlington-Bristol town line. Beneath its spreading branches, the Native Americans traded their wares with the settlers, who congregated at the nearby tavern. During the years prior to 1785, when New Cambridge and West Britain were negotiating to form one town, many meetings were held in the shade of the oak. In May 1785, a petition for incorporation was sent to the Connecticut General Assembly, which bestowed upon the new town the name of Bristol.

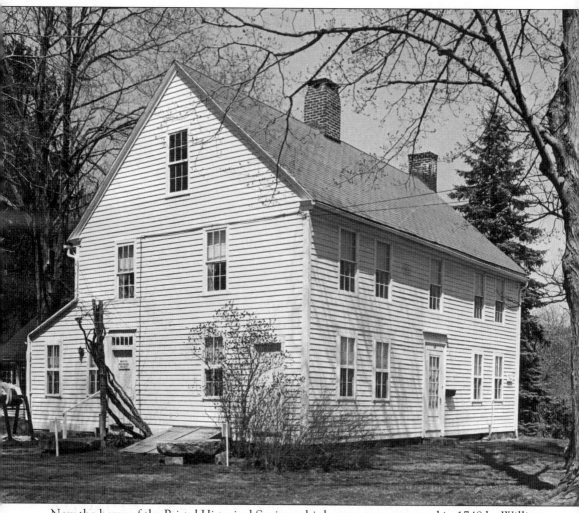

Now the home of the Bristol Historical Society, this house was constructed in 1748 by William Barnes after he received the land as a gift from his father, Ebenezer Barnes. The Terrys' first association with the home came in 1828, when Samuel Terry, who engaged in clock making, purchased it.

Two
THE CLOCK INDUSTRY

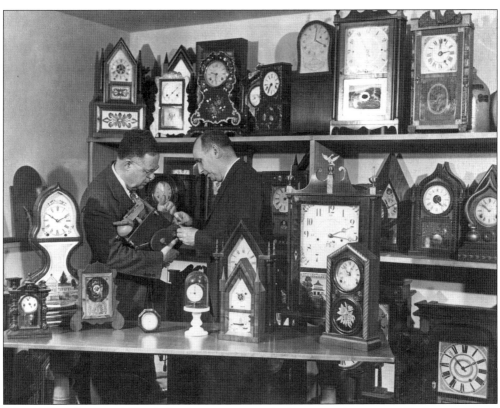

Edward Ingraham and Frank Little examine a clock at the American Clock and Watch Museum. Clock making was one of the earliest and most important industries of Bristol. George Mitchell and his fleet of peddlers sold Bristol clocks as early as 1796. Mitchell also began convincing other clock makers to relocate to Bristol by offering to sell them land in exchange for clock parts. In this way people such as Chauncey Jerome, Samuel Terry, and Elias Ingraham set up clock factories and, by 1835, there were 16 clock factories here, producing more than 100,000 clocks a year.

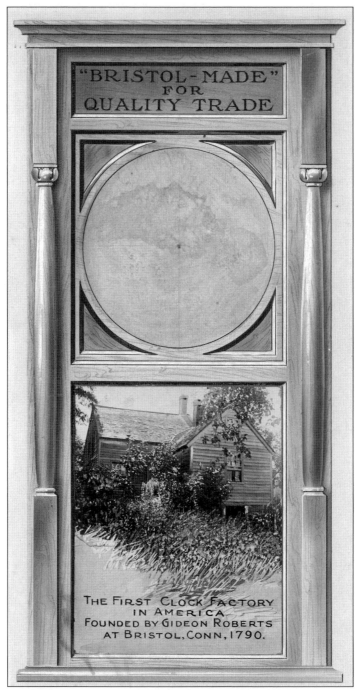

"BRISTOL-MADE"
FOR
QUALITY TRADE

THE FIRST CLOCK FACTORY
IN AMERICA
FOUNDED BY GIDEON ROBERTS
AT BRISTOL, CONN, 1790.

Gideon Roberts was born in New Cambridge (Bristol) in 1746 and began making clocks after the Revolutionary War. His factory was located on the northern slope of South Mountain and was arguably the first clock factory in America. By the year 1812, he had as many as 400 wooden clock movements in the process of manufacture at the same time. Roberts never received the credit that may be due to him, for he died an untimely death in 1813, stricken with typhus.

18

This is an example of one of the many clocks peddled by George Mitchell. Although Mitchell was not actually a clock maker, his name appears inside many of the clocks that he sold. Because of his sense of business, Bristol clocks could be found in even the remotest cabins in the country. To George Mitchell, more than to any other man, Bristol is indebted for its prosperity and growth.

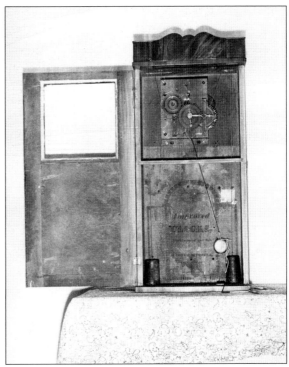

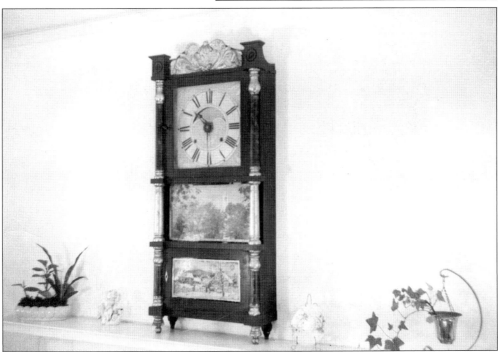

This clock was produced by the Case, Willard and Company in 1835. The firm went out of business in the depression of 1837, and Case later became associated with John Birge in the clock industry. The clock pictured here has a case of mahogany and gold leaf. The mechanism is run by weights and includes an alarm, which is also operated by means of a weight.

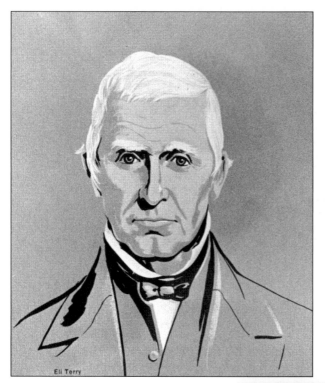

Eli Terry

Eli Terry of Plymouth had a lasting influence on the clock-making industry of Bristol. In 1816, Terry produced a wood-movement shelf clock and designed its case with turned columns on the sides and, below the dial, a tablet of glass with reverse painting, usually a scene featuring rivers, trees, or houses. Known as the pillar-and-scroll clock, this product gave a boost to the existing clock industry of Bristol and, soon, new clock-making factories sprang up along the Pequabuck River.

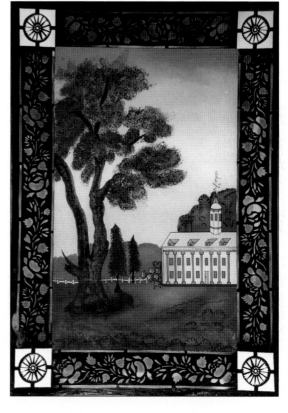

In 1828, Samuel Terry, a brother of Eli Terry, bought the old gristmill property now known as the Terry Homestead. He paid for the property in Terry patent clocks with mahogany cases and began manufacturing clocks in partnership with his son, Ralph Terry. The tablet of glass with the reverse painting, shown here, is on a pillar-and-scroll clock manufactured by Samuel Terry, currently on display at the Bristol Historical Society.

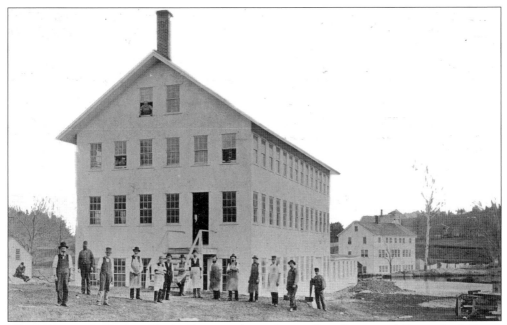

The Solomon C. Spring Clock Shop was located near East Street and Riverside Avenue. Solomon Spring and Mr. Dickens are in the foreground. In the third story, looking out of the window, is Elisha J. Thompson. The Spring Clock Shop merged with E.N. Welch, forming Welch, Spring & Company, and manufactured fine regulator clocks.

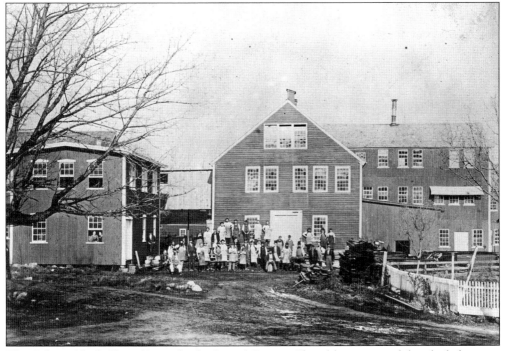

The Atkins Clock Shop (formerly the Bristol Baptist Church) was one of the clock factories destroyed by the economic depression of 1857. Although the depression lasted only a short time, it was disastrous to the clock makers of Bristol.

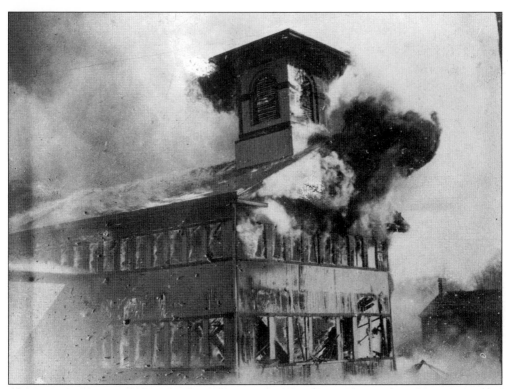

Elisha N. Welch used his business connections to survive the depression of 1857 and invested in J.C. Brown and Company. By 1860, Welch owned the largest firm in town. After his death, in 1887, the company was less prosperous. The fire pictured here occurred on March 17, 1899, and drove the company into further decline.

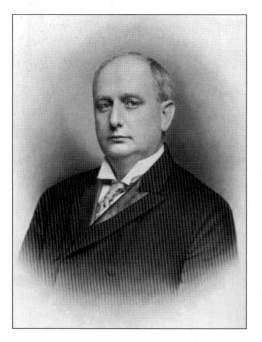

William Sessions was born in Bristol in 1857. He entered his father's business but soon became eager to have his own company and took over the Bristol Foundry. In 1902, when the E.N. Welch Clock Company was in danger of bankruptcy, Sessions came to the rescue. He took it over and changed its name to the Session Clock Company. Under his management, the plant recovered and expanded, becoming one of the foremost clock companies in the country.

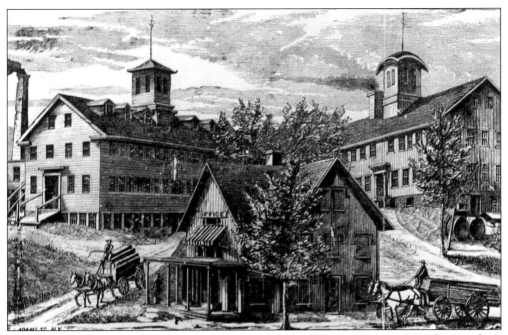

This is the E. Ingraham & Company plant on North Main Street *c*. 1875. The Ingraham Company expanded by making "dollar watches" the same way that it made clocks, which insured the company's success in the 1900s.

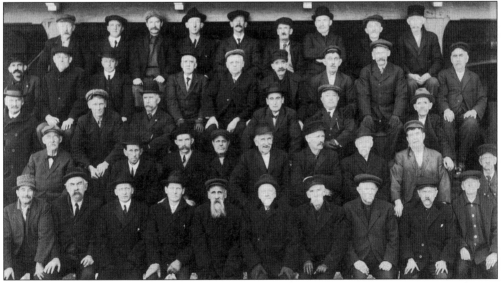

Veteran employees of the Ingraham Company pose for their photograph in 1915. They are, from left to right, as follows: (first row) A. Farrer, S. O'Connell, W. Merrill, J. Merrill, P. Bromley, W. Adams, C. Eddy, W. Chapin, G. Schilling, and E. Smith; (second row) J. Hynds, F. Payne, C. Wallin, J. Moquin, W. Kane, M. Green, E. Woodford, C. Halloran, and E. Woodruff; (third row) R. Culver, E. Merrill, P. O'Conner, E. Bradley, F. Pfenning, and P. Farrell; (fourth row) A. Moquin, P. Lynch, E. Smith, M. Soule, A. Rawson, O. Thiery, N. Duquette, F. Miles, and S. Ladd; (fifth row) H. Murnane, A. Vogel, P. Kelley, A. Ackerman, A.B. Ackerman, N. Sparks, C. McCarthy, J. Quinn, and P. O'Keefe.

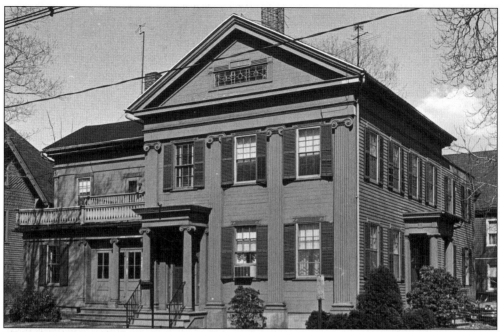

The house at 122 Maple Street is a fine example of the elegant homes built by Bristol's clockmakers. The Lawson Ives House was constructed in 1833. In 1844, J.C. Brown purchased the home and used it as a design on his clock tablets.

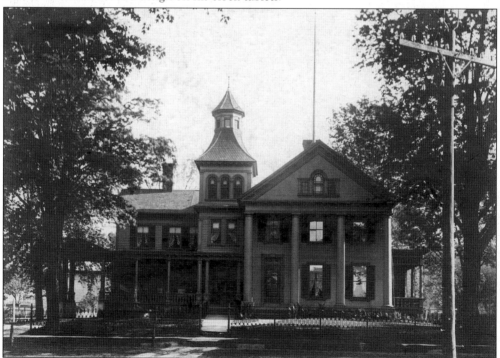

The house at 126 South Street was once the home of Chauncey Jerome, a prominent clock maker. It was later sold to Edward Dunbar. In the 1880s, local architect Joel Case added the cupola and the Victorian trim. This building is currently the home of the Bristol Elks Club.

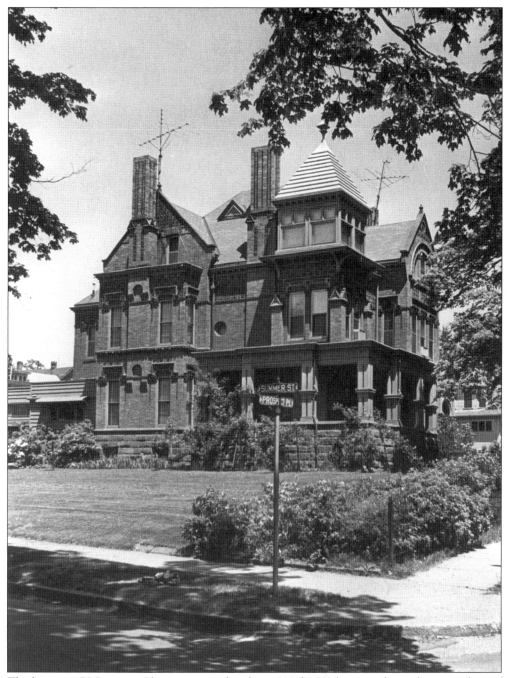

The house at 72 Prospect Place was completed in 1892 for Walter Ingraham, then president of the Ingraham Clock Company. It is an elaborate high-style Queen Anne house constructed of brick and terra cotta with a base of brown granite.

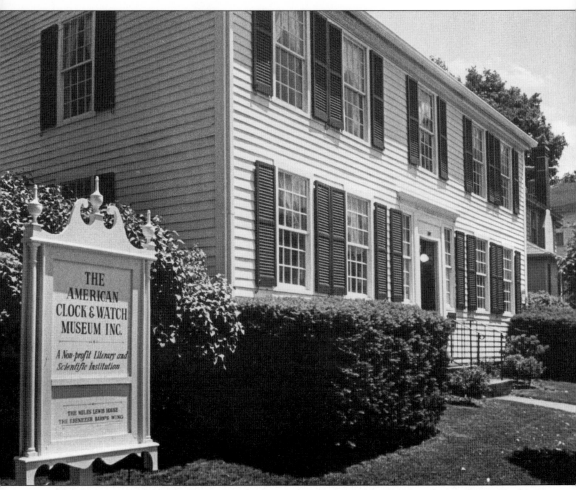

The house at 100 Maple Street was built in 1801. It is a plain but handsome Georgian house that retains all of its original exterior details. It is currently the home of the American Clock and Watch Museum, which is the best source of information on Bristol's history of clock making and on the history of clocks in general. The interior of the house is filled with hundreds of operating clocks, and the rear wing uses the trusses and paneling saved from the 1728 Ebenezer Barnes house.

Three

INDUSTRIAL BEGINNINGS

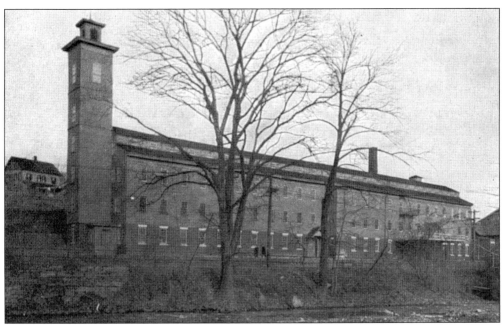

After the Panic of 1837, businessmen looked to diversify the products they manufactured. The first line of manufacture other than that of clocks was knit underwear. The Bristol Manufacturing Company, which was located on Riverside Avenue, manufactured satinette, a cotton wool fabric with a smooth wool finish. In 1856, the company changed its product to knitted shirts and drawers. The company prospered until the American public tired of knitted underwear, and then it closed in 1923.

Another of the new businesses to be founded was the and N.L. Birge Sons & Company knitting mill. Located on Pond Street and founded in 1850 as the Bristol Knitting Company, the mill engaged in the manufacture of fine men's underwear until 1931.

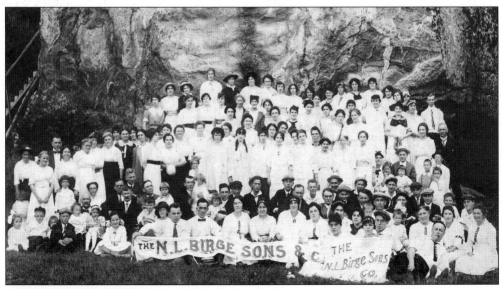

The N.L. Birge Sons & Company outing at Lake Compounce was a yearly event.

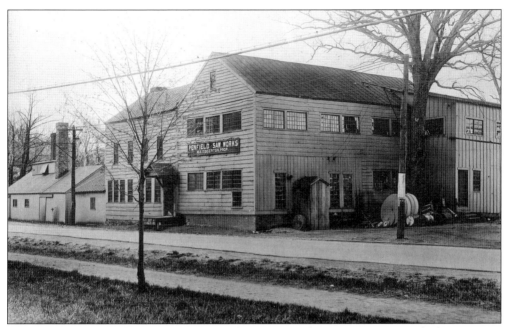

Irenus Atkins started the Penfield Saw Works on Riverside Avenue in 1834. The business was later reorganized as the Porter Saw Company and later still as the Bristol Saw Company. In 1879, it was purchased by E.O. Penfield and operated by him until 1899, when it was acquired by M.D. Edgerton. Since that time, it has been known as the Penfield Saw Works.

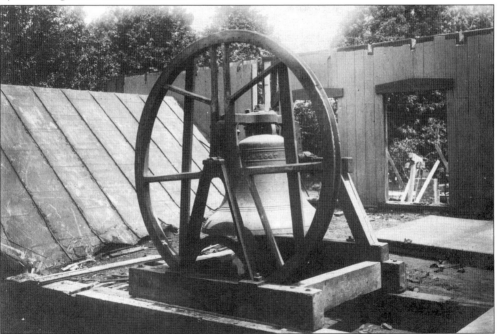

The Dunbar Bell was first used at the Bristol Copper Mines. It was purchased in 1858 by Col. Edward Dunbar and was hung in the Dunbar Spring Company, which produced clock springs. At 9:00 every night, the bell was rung 99 times and, over time, that became the unofficial curfew.

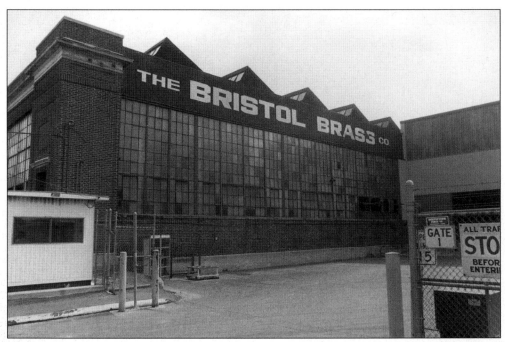

Another important manufacturing enterprise that derived directly from the clock-making industry was brass production. The clock makers required great amounts of brass, and they united with other consumers of brass to form the Bristol Brass and Clock Company in 1850. In 1903, the name was changed to the Bristol Brass Company.

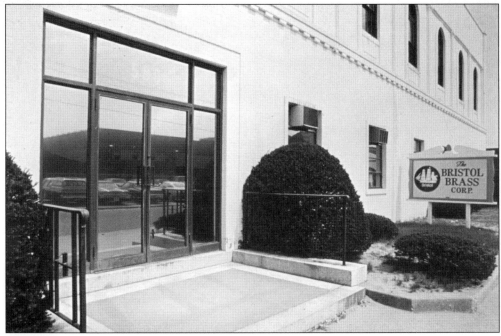

The name of the Bristol Brass Company was changed to the Bristol Brass Corporation, and the plant was modernized to fill orders during World War I.

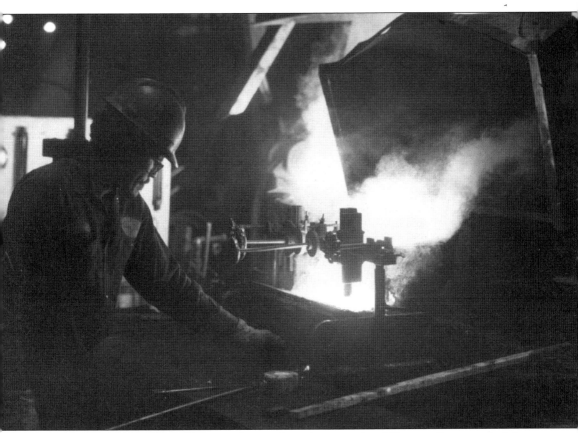

The Bristol Brass Corporation engaged in making brass in the different alloys required by customers and rolling it out into plates of the required thickness and width.

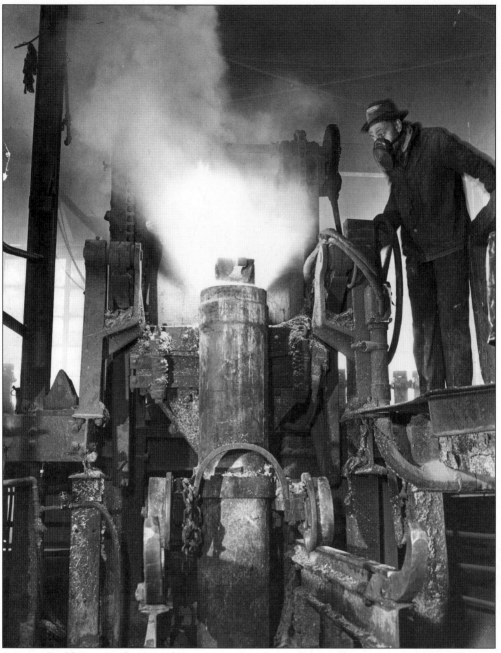

During World War II, the Bristol Brass Corporation was busy with wartime production but, in the early 1980s, the demand for brass decreased and the company closed.

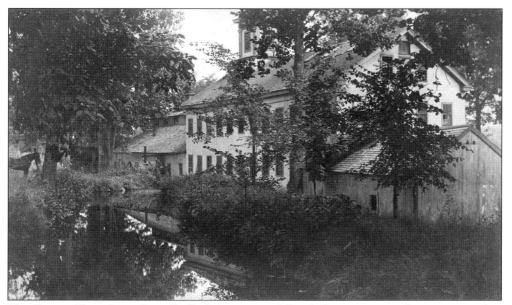

The Burner Shop, located on Stafford Avenue and Brook Street, was another company that utilized brass. The company manufactured kerosene lamp burners, which were used until the adoption of electricity.

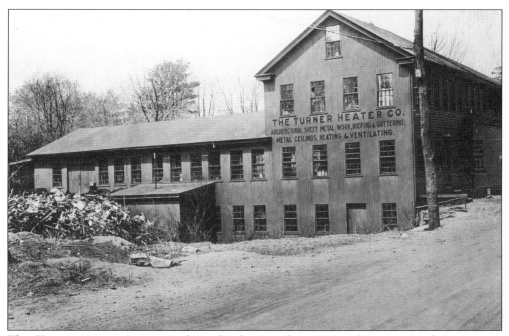

The Turner Heater Company, formerly the Ingraham Case Shop, on Pond Street, was organized in 1890. The company manufactured furnaces, smokestacks, blowers, and metal roofing.

The American Silver Company was located on Main Street (note the Main Street Bridge) and was a spin-off of the Bristol Brass and Clock Company in 1901. The company manufactured silver flatware and was known as the Spoon Shop.

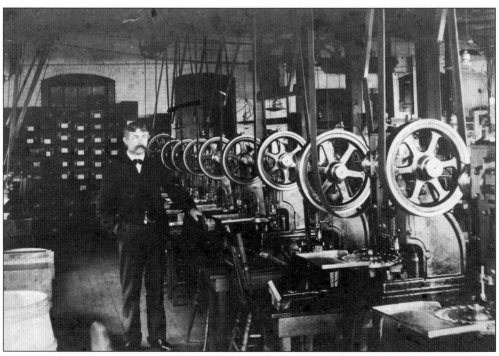

In 1914, the Bristol Brass Company distributed American Silver Company stocks to its shareholders as a special dividend. This is the interior of the American Silver Company.

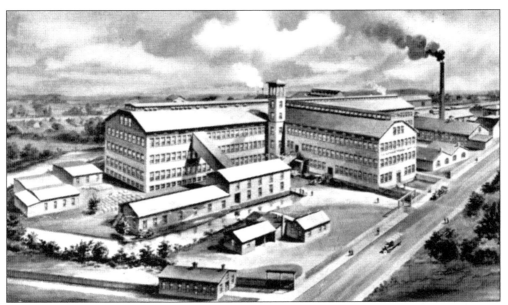

In 1912, the National Marine Lamp Company purchased the Burner Shop, located on Stafford Avenue and Brook Street. This company thrived during the shipbuilding activity of Word War I.

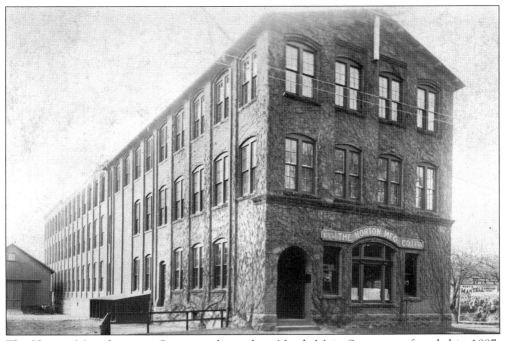

The Horton Manufacturing Company, located on North Main Street, was founded in 1887. The company specialized in the manufacture of steel fishing rods and also produced golf clubs and antennae. The business began to decline after the invention of fiberglass fishing poles. It was sold to the Bristol Machine Tool Company in 1953.

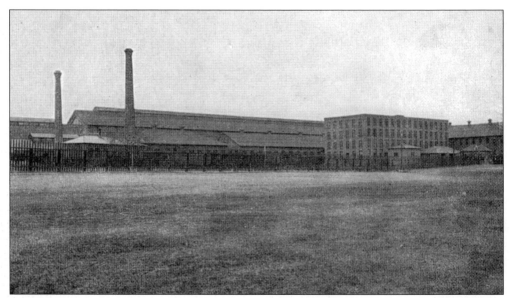

Sessions Foundry was completed in 1895 and was a model plant of its day. Located on 30 acres of what is now the Bristol Commons, the plant produced small and large castings.

The Humason Manufacturing Company of Forestville was a producer of springs. The plant stood on the site of the old Boardman-Dunbar clock factory. In 1950, the company became a subsidiary of the Stanley Works of New Britain.

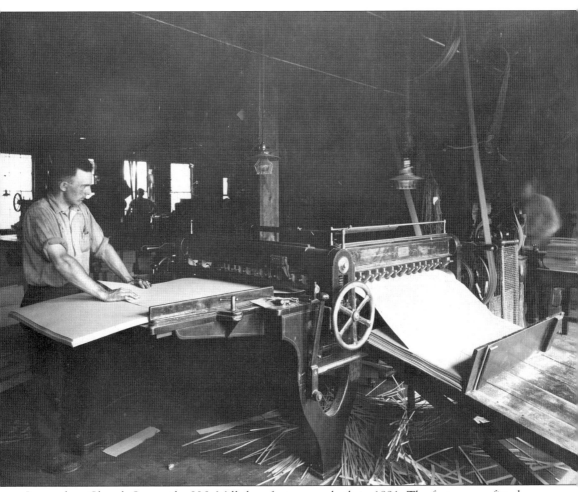

Located on Church Street, the H.J. Mills box factory was built in 1891. The factory was fitted with steam power and the most modern box-making machinery of its time.

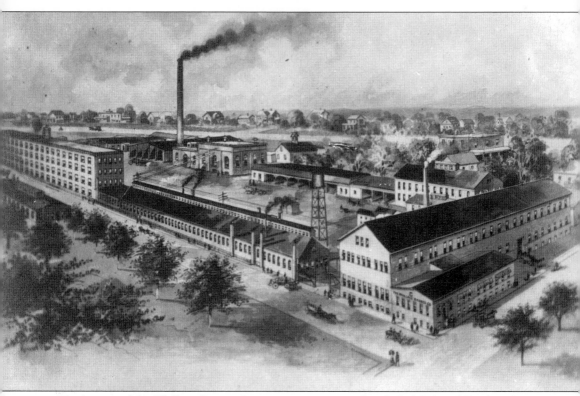

The history of the Wallace Barnes Company is intertwined with Col. Edward Dunbar. Prior to 1845, all springs for the clock industry were imported from France but, in 1847, Barnes and Dunbar began manufacturing springs. Ten years later they began making hoops for the fashionable hoopskirts, and the Barnes building was called "Crinoline Hall." In 1866, Wallace Barnes bought out Dunbar and, from that time on, the two companies were separate. Barnes continued the manufacture of springs on Main Street.

Four

NEW DEPARTURE

In 1888, two brothers from Florida, Edward D. Rockwell and Albert F. Rockwell, arrived in Bristol to begin manufacturing their new invention: a doorbell that operated by clock movements. They were attracted to Bristol because of its reputation as a clock town. The Rockwell brothers' first small factory was located in the back room of the Thompson Clock Factory on Federal Street. This one-room factory was called the New Departure Bell Company.

The doorbell venture was very successful, and the New Departure Bell Company soon began making all types of bells: alarm, cable car, tea, fire, and bicycle bells.

NEW DEPARTURE DOOR BELLS

Price List of Rotary Door Bells without Turn Plates.

ROTARY BELL GONG.

Regular Pattern, Bell Metal Gong, Iron Base.

No.	Size.		Finish of Gong.				Per Doz. Without Plate.
91	3	inch	Nickel plated,	.	.	.	$12.50
92	3	"	Old Copper,	.	.	.	12.50
93	3	"	Bronze,	.	.	.	12.50
01	3½	"	Nickel plated,	.	.	.	15.00
02	3½	"	Old Copper,	.	.	.	15.00
03	3½	"	Bronze,	.	.	.	15.00

Nickel Steel Gong, Stamped Steel Base.

No.	Size.		Finish of Gong.		
41	3 inch		Nickel plated,	.	Prices on application

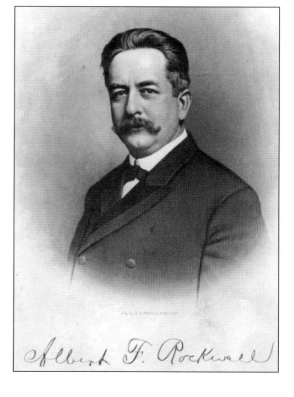

Albert F. Rockwell

In 1890, the Rockwell brothers leased a brick building east of North Main Street, changed the name to the New Departure Manufacturing Company, and expanded their product line to include bicycle lamps. After Edward Rockwell retired in 1895, Albert Rockwell became New Departure's dominant figure and the company continued to grow and prosper.

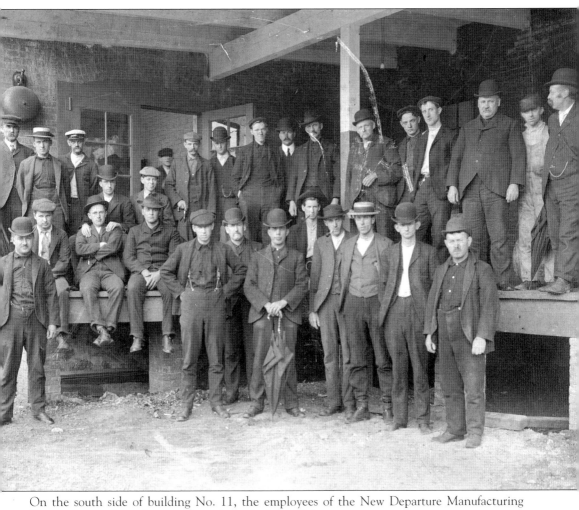

On the south side of building No. 11, the employees of the New Departure Manufacturing Company pose for a photograph at the end of the 19th century.

The patenting of the New Departure coaster brake in 1898 created such a demand for coaster brakes that the company had to limit its products to two items only: coaster brakes and bicycle lamps.

Within a decade, the coaster brake became standard equipment on many American-made bicycles and also saw extensive use in Europe. This is a photograph of the coaster brake assembly line.

Testing coaster brakes on Seymour Street, the New Departure Company continued to redesign and improve its product.

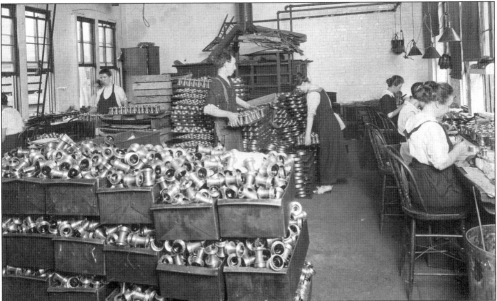

Because of the continued demand for coaster brakes, it was soon the dominant product of New Departure. Improvements were made to the assembly line and coaster brake production soon exceeded 5,400 per day.

Employee Tom Caffey is shown assembling New Departure coaster brakes.

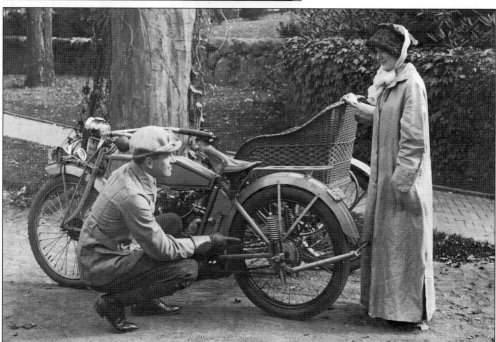

C.P. Weldon tests the application of coaster brakes on motorcycles. New Departure was always seeking new product lines and improvements.

This is the New Departure heating plant under construction on North Main Street. As the company continued to prosper, it expanded its North Main Street facility and built new plants in the surrounding areas.

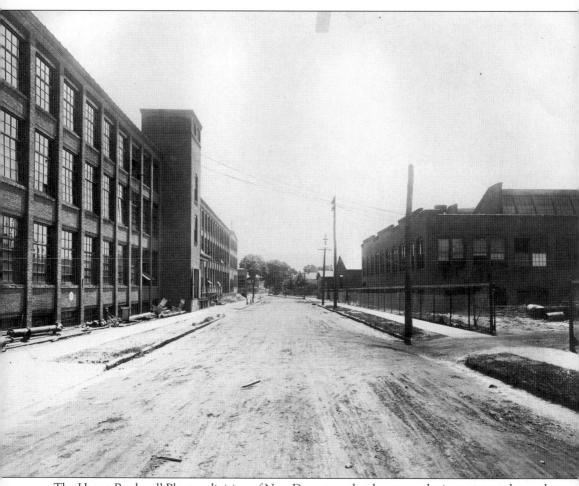

The Haupt-Rockwell Plant, a division of New Departure that began producing cars, was located to the right of the New Departure plant on Valley Street.

This photograph taken from Summer Street shows the New Departure buildings on the east side of North Main Street. In the distance are Brightwood Hall and the West Cemetery.

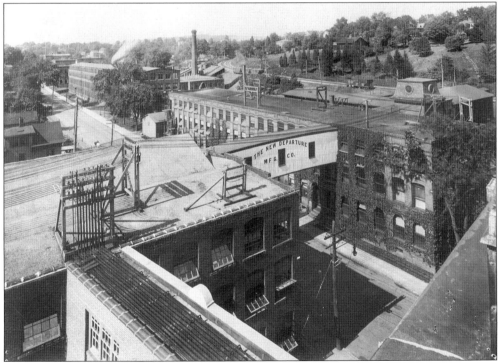

The New Departure mechanical building and coaster brake building were on North Main Street. An overpass connected the two buildings. Notice the Ingraham Company to the left.

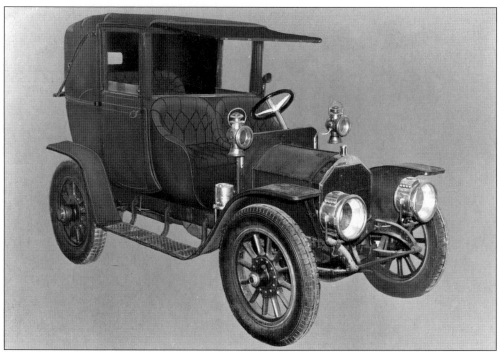

In 1908, New Departure began making automobiles. The company manufactured the very first taxicab in the United States. Placed in service in New York City, Rockwell Cabs, as they were called, were painted the familiar yellow that is still in use on taxicabs to this day.

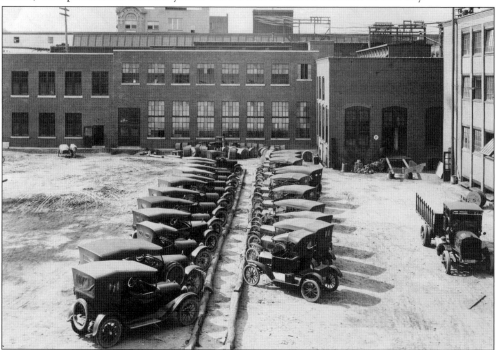

Although New Departure built quality automobiles, the product did not prove profitable. After only two years, the company gave up building cars.

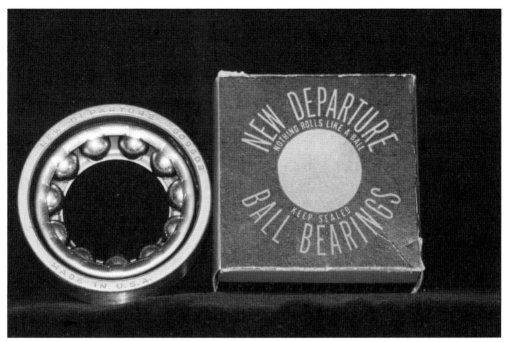

The rapid growth of the automobile industry created a great demand for ball bearings. Again, Albert Rockwell's inventive genius brought business to his company.

Louis Chevrolet, the famous Indianapolis race driver from France and one of the founders of the Chevrolet Company, visited the New Departure plant. The Rockwell bearing became the preferred ball bearing of the better grade of cars, and bearings soon became New Departure's principal product.

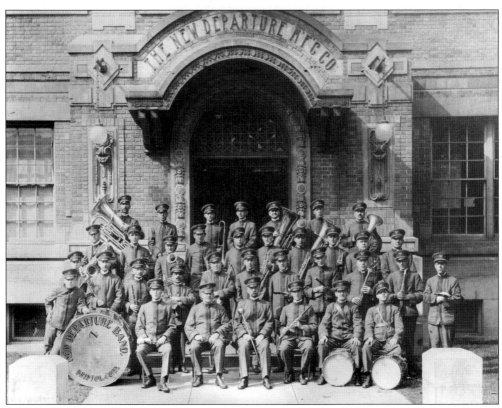

The New Departure Band was a familiar sight at parades and special events.

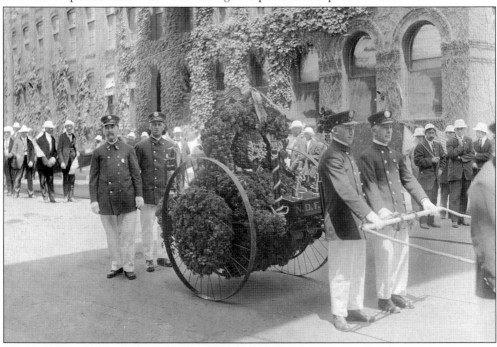

The New Departure Fire Department marches in the Old Glory Day Parade on July 4, 1918.

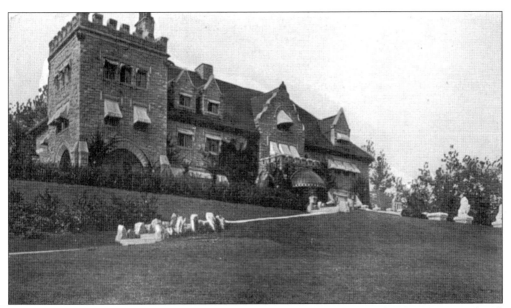

New Departure made the Rockwells a very wealthy family. Albert and wife Nettie Rockwell resided at Brightwood Hall. The 21-room granite castle was built for Helen Atkins-McKay but was left unfinished at her death. Brightwood was situated above West Street at an elevation of 500 feet above sea level to secure freedom from the dust of the roads.

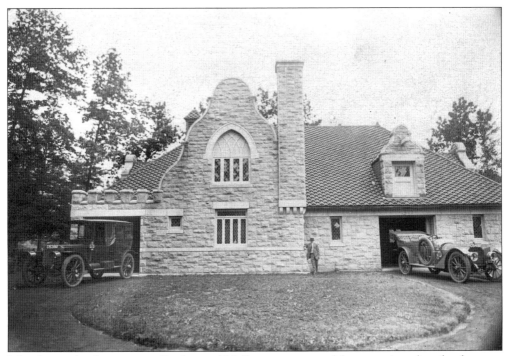

Like the castle, the garage at Brightwood Hall was constructed from granite taken for the most part from the grounds on which the structure was built.

Believing that Albert F. Rockwell was more of an inventor than a businessman, Charles T. Treadway used his interest in New Departure to remove its founding father in 1913. Rockwell was replaced by his brother-in-law Dewitt Page, pictured here. In 1916, Treadway initiated a stock-swap merger that made New Departure a division of the auto parts manufacturer United Motors. Page served as the company's general manager until his retirement in 1933.

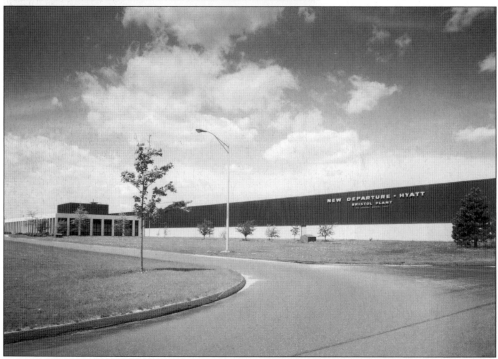

In 1965, New Departure announced plans to consolidate all of its plants into one unit. Fearing the loss of such a large employer and taxpayer, Bristol paid New Departure a subsidy of $15 million to ensure that the company stayed in town. Built in 1969, the new Bristol plant unfortunately was closed in the 1980s.

Five
MODES OF
TRANSPORTATION

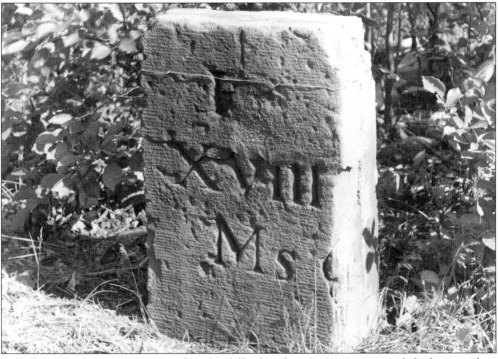

Early Bristol industry was hampered by the difficulty of getting its tinware and clocks to market. In 1804, the Middle Road Turnpike Company constructed a turnpike through Bristol to meet the transportation demands. This marker, located near the vicinity of Terryville Avenue and Hill Street, indicates 18 miles to Hartford, which was the principal port for Bristol at the time. Route 6 follows the old turnpike route. Because of the turnpike's presence, the north side became the town's business center.

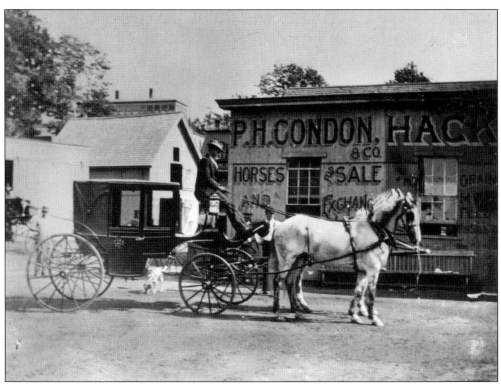

The horse was the principal means of transportation. At Patrick Condon's Livery Stable, it was not unusual for 100 hacks to be used daily.

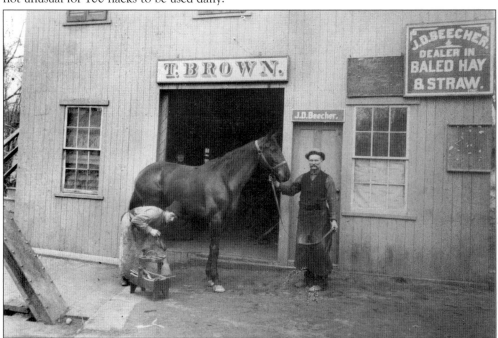

Because of the dependency on the horse for transportation, everyone knew Tom Brown, the blacksmith, whose shop was located on Main Street.

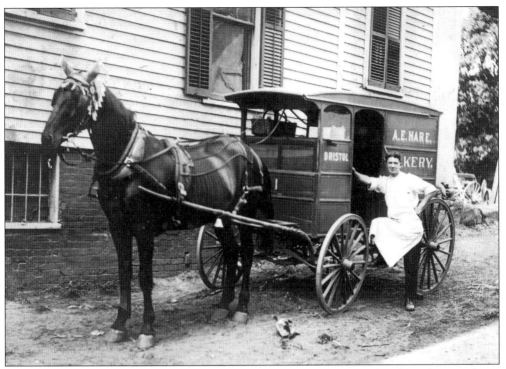

Small businesses, such as the A.E. Hare Bakery, depended on horses to distribute their products.

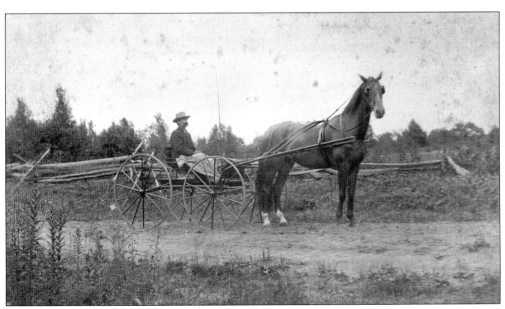

Of course, the individual got around town on foot or with the aid of a horse. Here, William Buckley drives his horse and side-bar road wagon through Forestville.

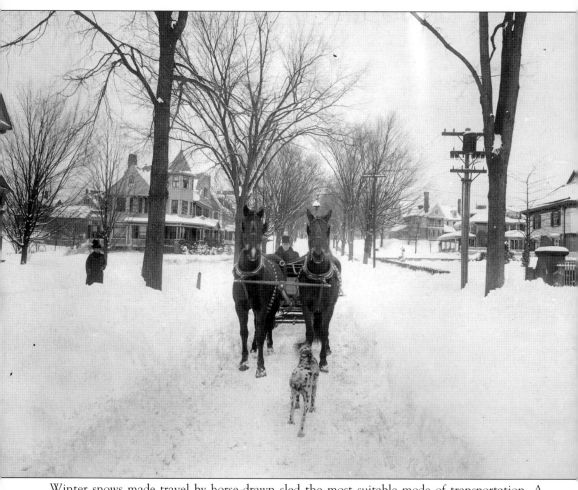

Winter snows made travel by horse-drawn sled the most suitable mode of transportation. A stately gentleman drives his sled down Bellevue Avenue, accompanied by his Dalmatian.

The greatest improvement to freight transportation in the 19th century was undoubtedly the railroad. The Providence, Hartford and Fishkill Railroad reached Bristol in 1850. The station was located on the south side of town, and the area gradually replaced the north side as the business center. The original station, seen here, was located at the corner of Main and Prospect Streets. It burned to the ground during a lightning storm.

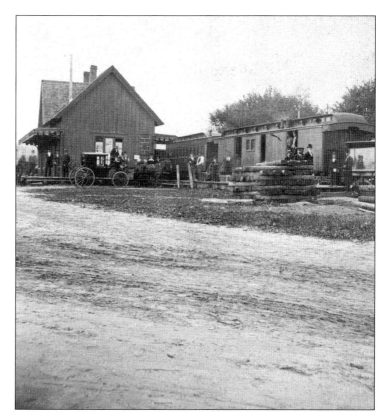

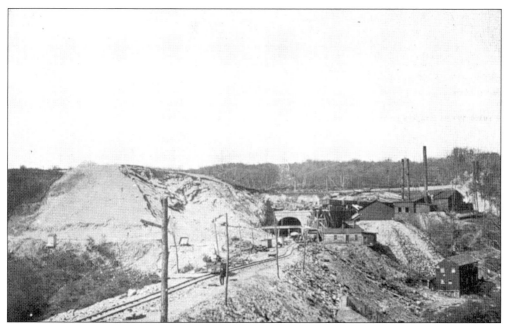

By 1855, the railroad line continued on to Waterbury via the longest train tunnel in the state of Connecticut. Many Irish immigrants were attracted to Bristol for the construction of this tunnel. The tunnel is still used today by the Guilford Rail System.

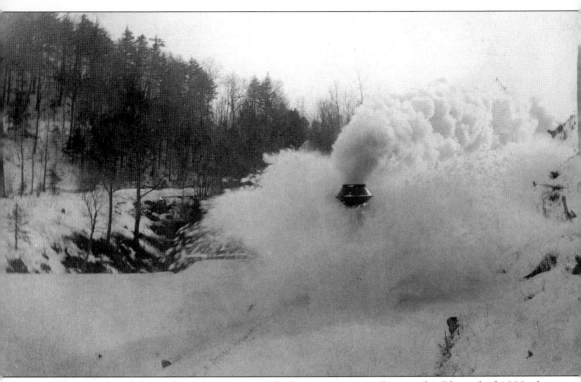

The weather did not always cooperate with the train service. During the Blizzard of 1888, the North Side Rock-Cut, which was a 25-foot-deep cut in the bedrock near Burlington Avenue, completely filled with snow, making the track impassable for four days.

As the population grew, railroad grade crossings became dangerous places. An especially dangerous crossing was the one at Main Street. On rainy days many horse teams got stuck in the mud.

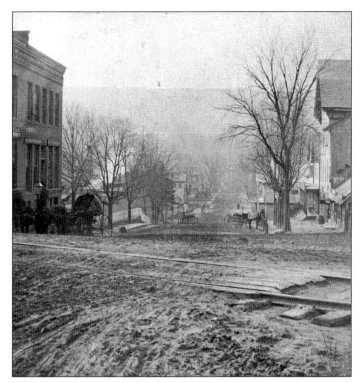

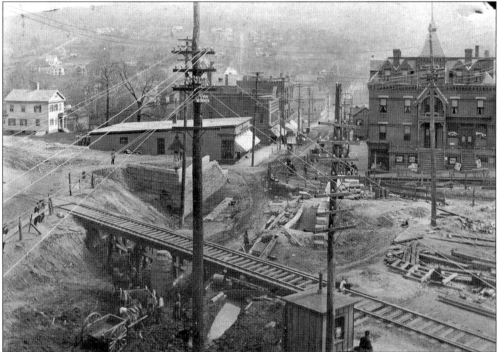

Because of the dangerous conditions, the then New York, New Haven, and Hartford Railroad was forced to take action. The remedy was to lower Main Street and to have the train track pass above it. This construction took place in 1900.

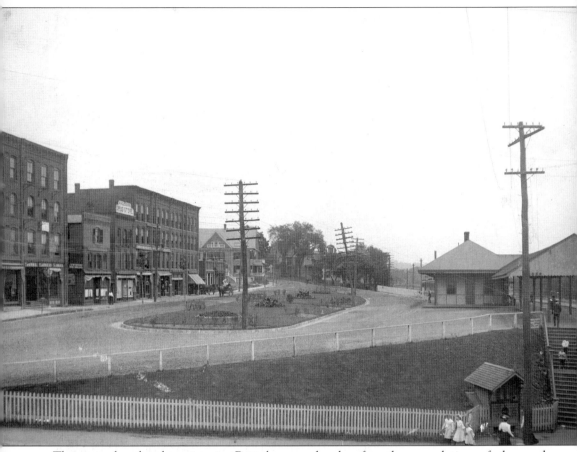

The second railroad station in Bristol, seen shortly after the completion of the road construction, was a disappointment to residents. Other sites, such as Thomaston, received beautiful brick structures during the same era; so, Bristol felt slighted when the New Haven Railroad decided to built its station in wood.

In the late 19th century, a new type of human-powered vehicle began to grow in popularity: the bicycle. George E. Moulthrop of Hull Street poses with his bicycle, a nickel-plated high wheeler. After Moulthrop won $200 in the Louisiana lottery, he traveled to Hartford and spent the entire sum on this beautiful vehicle. The photograph was taken on the day after he returned from Boston via a four-day bicycle ride.

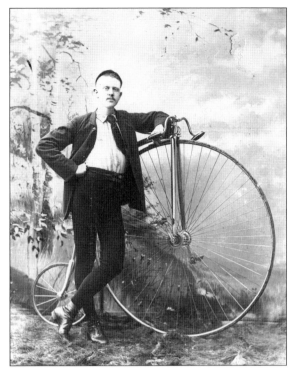

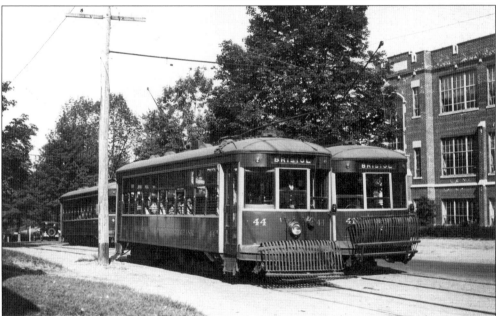

The Bristol and Plainville Tramway Company was chartered in June 1893. It provided individuals with transportation between the two towns, as well as a loop around Federal Hill and a spur to Lake Compounce. This company also provided electricity, natural gas, and steam heat to businesses and residences until this portion of the business was sold to Connecticut Light and Power in 1927. The Bristol and Plainville Tramway Company ceased operation in 1932.

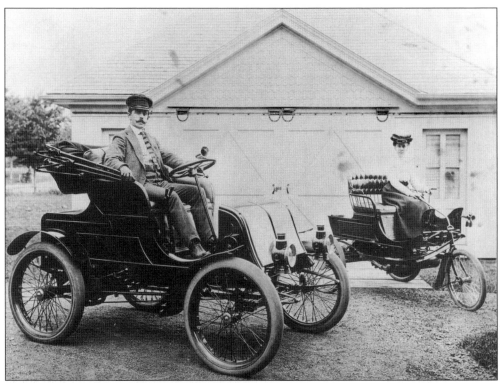

The dawn of the 20th century brought about the greatest advance in individual transportation: the automobile. Bristolites not only purchased automobiles but also manufactured them. F.N. Manross organized the Bristol Motor Car Company in 1902. This successful venture was absorbed into the Corbin Motor Car Company in New Britain. Here, Manross and his wife, Sylvia, are seen on board cars produced by his company.

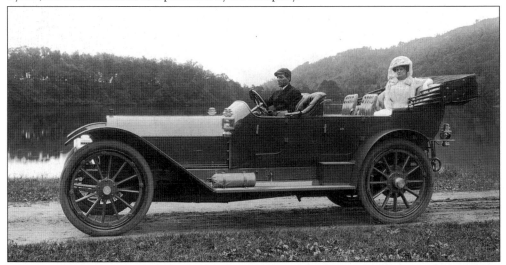

New Departure also entered the automobile market. The first automobile produced at the New Departure plant was the Haupt-Rockwell pleasure car. This car had the world's first engine cast in a single block, producing 85 horsepower. Here, Nettie Rockwell enjoys a chauffeured ride c. 1910.

Six

SERVING THE PUBLIC

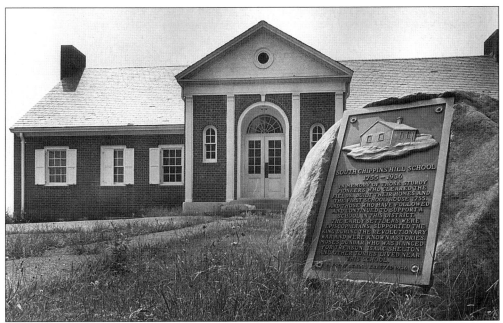

Service to the community has always been important in America since its Colonial days. Health, welfare, religion, and education were integral parts of the formation of every new settlement. When New Cambridge was settled, Connecticut law required every ecclesiastical society of 70 or more families to maintain a school. In 1754, the town of Farmington gave the society permission to build two schools, one on the east side of the Federal Hill Green and the other on Chippens Hill. Although the reason for the construction of two schools was to ease transportation problems in the winter months, this division was indicative of the religious and political differences of the times. This plaque honors those settlers who built the first school on Chippens Hill in 1755.

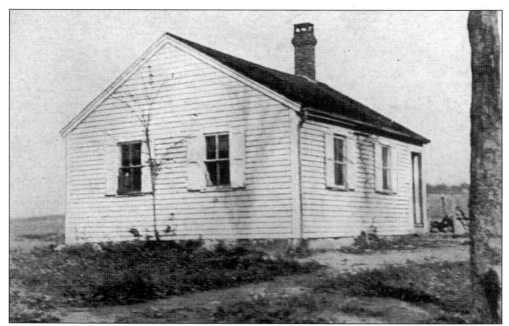

The Old School building on South Chippens Hill, was constructed by the Episcopalians, who were loyal to the British during the American Revolution.

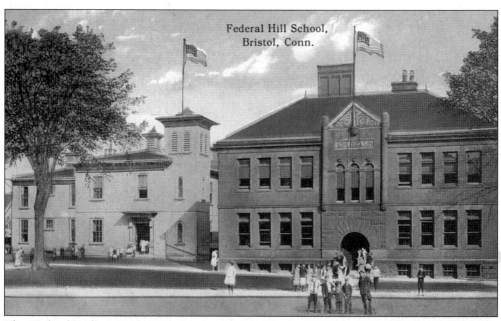

The Federal Hill School was constructed by the Congregationalists, who supported the American Revolution. It was also known as simply "the Academy." The school played an important role in the development of Bristol in its early days. The building pictured here was constructed in 1914, replacing the earlier smaller structure.

Thomas H. Patterson was the principal of the Federal Hill School from 1891 to 1941. Born in Suffield in 1859, he came to Bristol in 1890. The Federal Hill School had 234 pupils and 5 teachers when Patterson became principal. In 1894, an entirely new school was built to the south of the old wooden structure. In 1914, it became necessary to tear down the old building and build a new one to accommodate the growing population. The school was renamed the Thomas H. Patterson School in his honor at the annual First School District meeting on June 29, 1932. Patterson died on September 6, 1942, and school superintendent Karl A. Reiche ordered schools closed at noon on opening day in his memory.

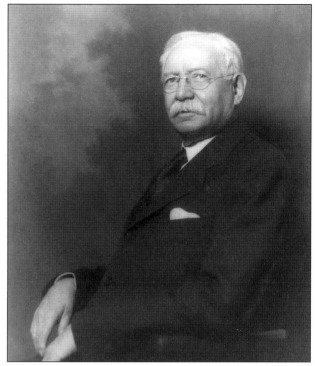

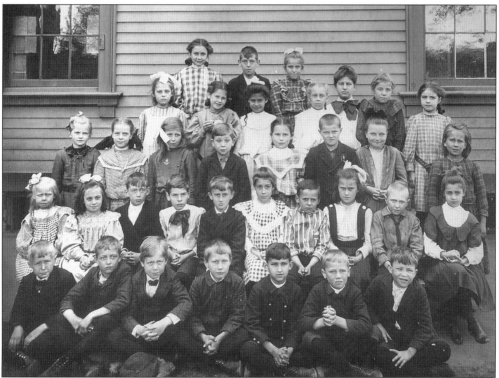

Bessie Keeler's third-grade class, of Room 4 at the Federal Hill School, poses outside on May 23, 1906,

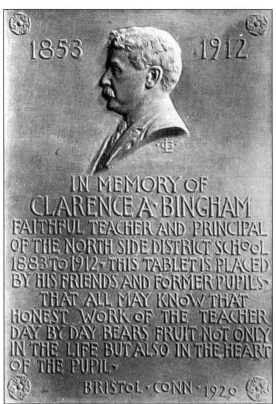

Clarence A. Bingham was born in Forestville in 1853 and was an itinerant teacher before accepting the position of principal of the North Side School.

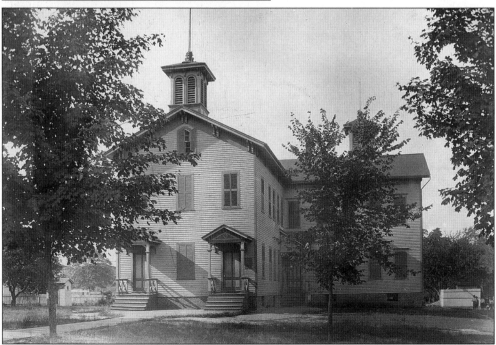

The North Side School was renamed for its former principal when the new schoolhouse was constructed on the corner of West Street and North Street in 1916.

Sarah E. Reynolds began her teaching career at the age of 16 but left to become a nurse in the Union Army during the Civil War. Upon her return to Forestville, she took charge of the education of the Forestville students. She often entertained the students at her Church Avenue home, encouraging them to develop interests in sewing, art, and elocution. She served as principal of the Forestville School until her retirement in 1896.

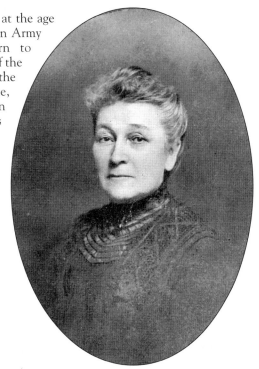

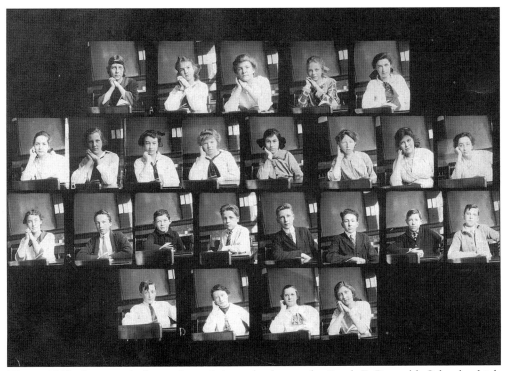

This c. 1913 photograph shows the eighth-grade class at the Sarah E. Reynolds School, which was named in honor of Forestville's long-serving teacher and principal.

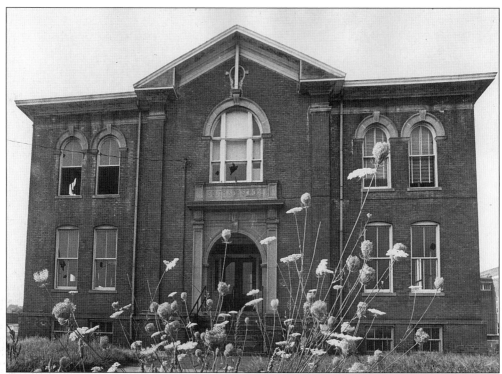

The South Side School on Church Street was closed in 1973 and now serves as the headquarters for the Board of Education.

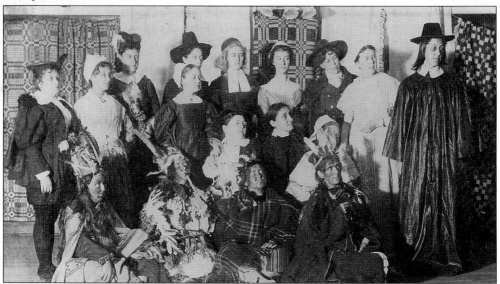

Shown are cast members of a Thanksgiving Day pageant that was presented at the South Side School in 1897. The are, from left to right, as follows: (first row) L. Richards, Mrs. Deacon, Miss E. Edwards, and Mrs. T.F. Barbour; (second row) Edith Ladd, Mary Root, and Alice Bartholemew; (third row) K. Hanson, Mrs. L. Goodwin, M. Marick, and Mrs. C.F. Barnes; (fourth row) Bessie Scott, Ellen P. Hubbell, Miss Walker, Mary Peck, Mrs. C. Cook, and Ellen Peck.

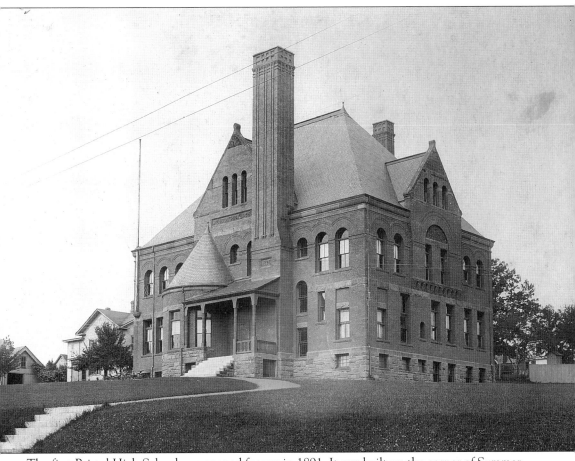

The first Bristol High School was opened for use in 1891. It was built on the corner of Summer Street and Center Street at a total cost for the land and building of $35,000.

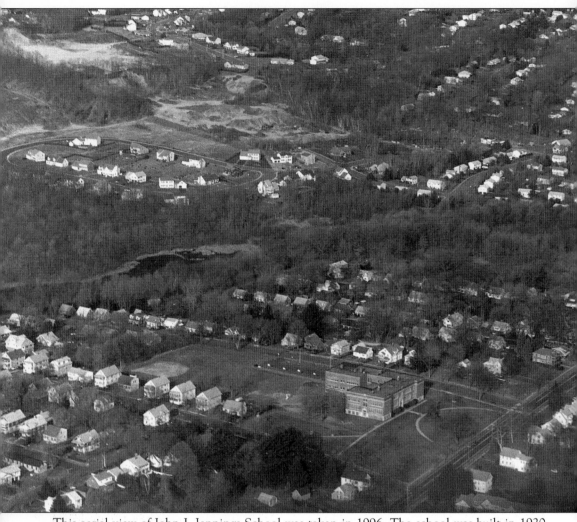

This aerial view of John J. Jennings School was taken in 1996. The school was built in 1920 and was named for John J. Jennings in honor of his contributions to education in Bristol.

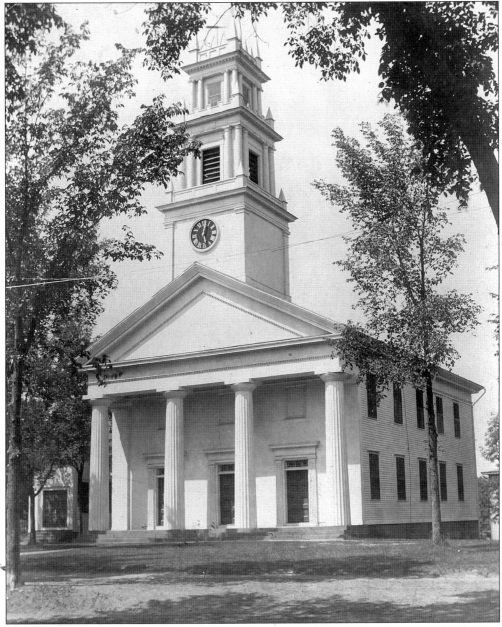

The First Congregational Church on Maple Street was dedicated on August 1, 1932. This church replaced the second meetinghouse, which was built in the 1770s.

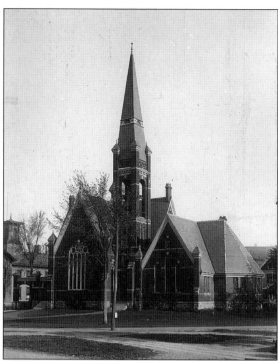

The Baptist church was built in 1880, on the corner of Church and School Streets. The spire was struck by lightning and had to be removed.

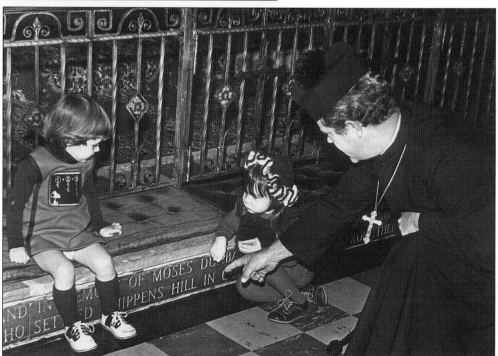

At the communion kneeler in Trinity Episcopal Church, Rev. Marcus Rogers is shown with Sarah White and Leah Huntington, planning for the bicentennial tour of the church. The original members of the church were the early settlers from Chippens Hill, including Moses Dunbar, a staunch Loyalist, the only man hanged for treason in Connecticut.

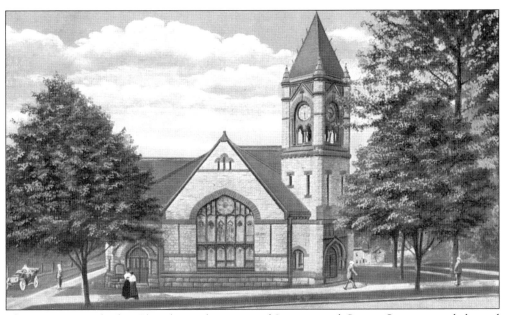

The Prospect Methodist Church, on the corner of Summer and Center Streets, was dedicated in June 1894. J.H. Sessions was a major contributor to the construction of the church.

The Confirmation at St. Joseph's Church is shown *c.* 1900, with Father Donnelly, who was pastor at that time. In 1855, St. Joseph's became the first Roman Catholic church to be established in Bristol.

The Mount Hope Sunday school was begun in 1884 by Hattie Utter. The Sunday school proposed the building of a chapel and, in 1889, the Mount Hope Chapel was built on Hill Street.

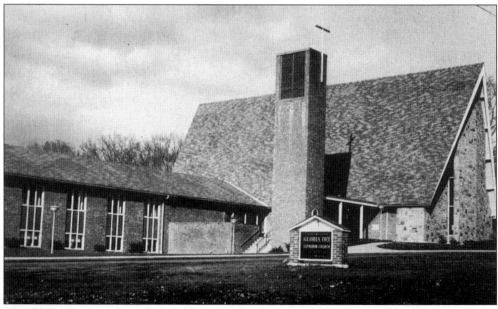

The Gloria Dei Lutheran Church of Forestville was dedicated on March 23, 1963.

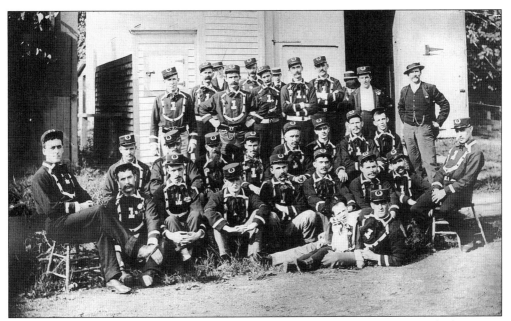

A series of costly fires occurred in the 1840s, one causing the loss of the Jerome Clock Factory, resulting in its subsequent relocation to New Haven. Through the efforts of Col. Edward Dunbar and Alphonse Barnes, a fire department was organized in 1853. Hose Company No. 1 is seen here posing for a group photograph.

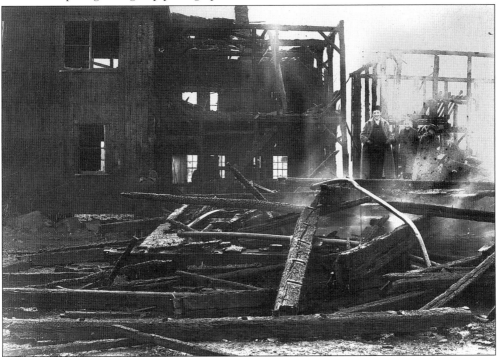

A fire at the Barnes Brothers clock factory added impetus to the improvement of the fire department. Col. Edward Dunbar and Alphonse Barnes procured Bristol's first hand fire engine, which formed the nucleus of the town's fire department.

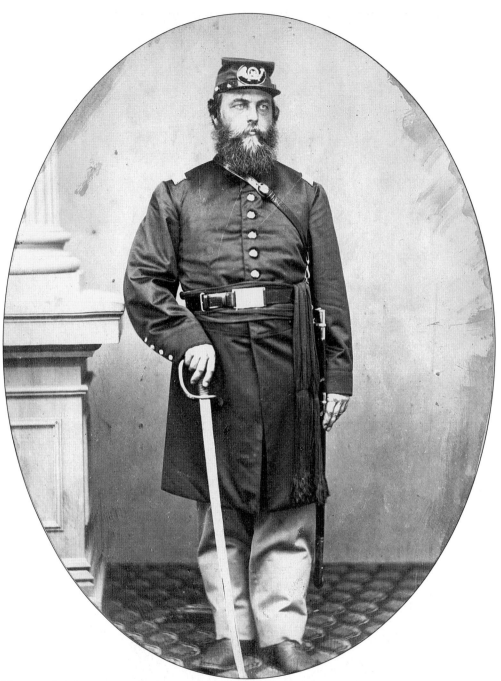

Newton S. Manross was born in Bristol in 1825 and graduated from Yale in 1850. After continuing his studies in Europe, he returned to the United States to work with his father. When the Civil War broke out, he accepted a commission as captain of Company K, 16th Connecticut Volunteers. In the company's first battle, the Battle of Antietam, the regiment was ordered to the front lines, where Manross was struck and killed by a cannonball.

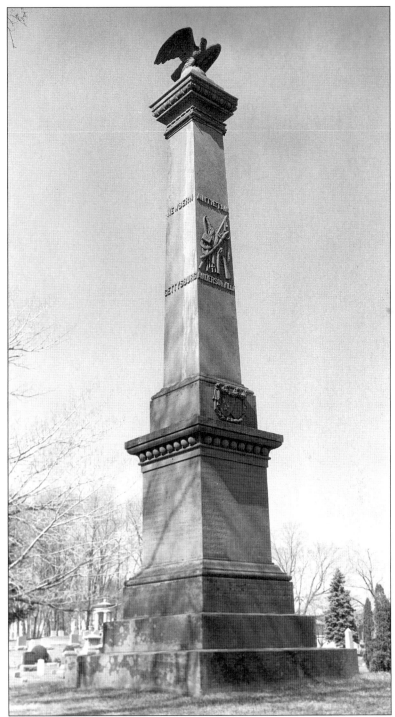

In 1865, the citizens of Bristol organized to erect this monument dedicated to those who lost their lives while preserving the Union. Standing 25 feet tall and topped by an American eagle, this monument in the West Cemetery was the first in Connecticut to honor those who lost their lives in the Civil War.

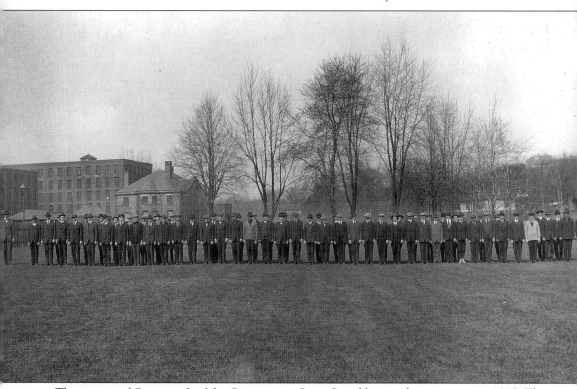

The recruits of Company L of the Connecticut State Guard line up for inspection in 1917. This company formed in response to the threat posed by the Great War (World War I). Capt. Ray K. Linsley was the commanding officer. William J. Malone served as first lieutenant and Edward Ingraham as top sergeant.

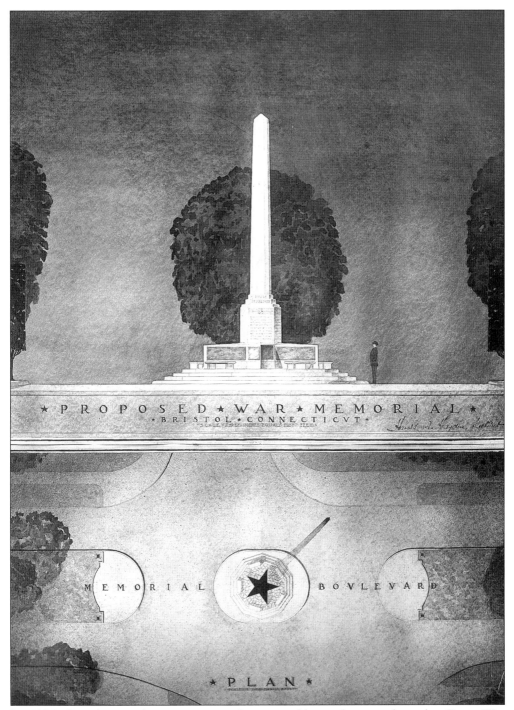

In 1924, Bristol erected a war memorial to its soldiers who served in the Great War (World War I). This monument is the centerpiece of Memorial Boulevard, which was laid out under the direction of Albert F. Rockwell.

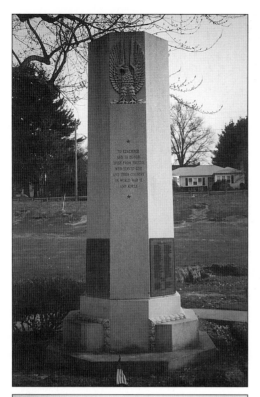

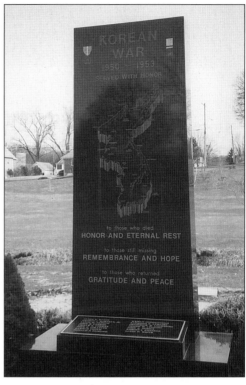

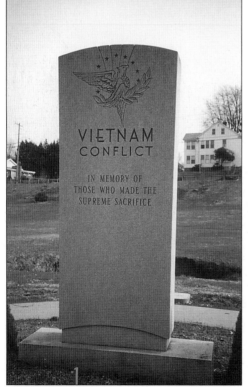

Unfortunately, the Great War was not the last war, and monuments have been erected along Memorial Boulevard to honor those who made the supreme sacrifice for their country. The boulevard is one of the most beautiful streets in Connecticut and is a focal point for the community.

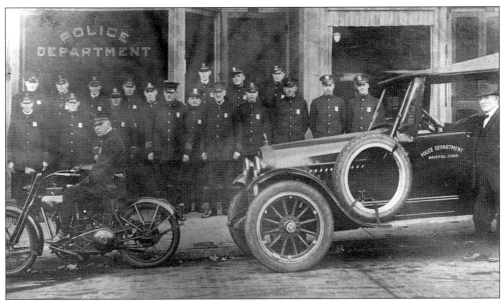
Bristol's police force poses for a photograph in front of the police department *c.* 1925.

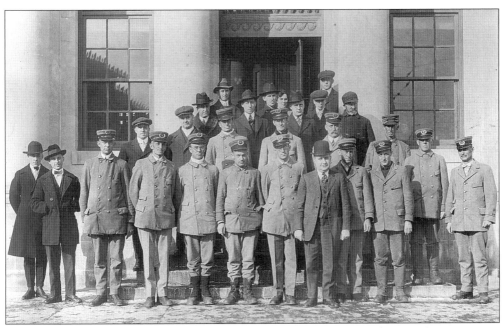
In front of the Bristol post office, the mail carriers pose for a photograph *c.* 1925.

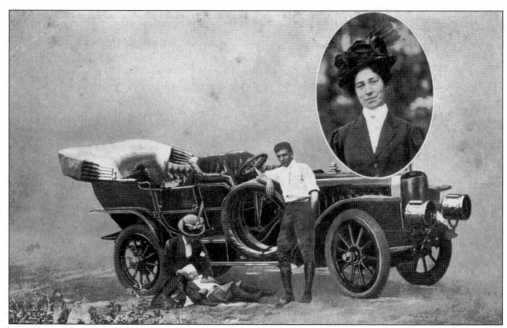

Mrs. Edson A. Peck organized the Bristol Visiting Nurses Association in 1908.

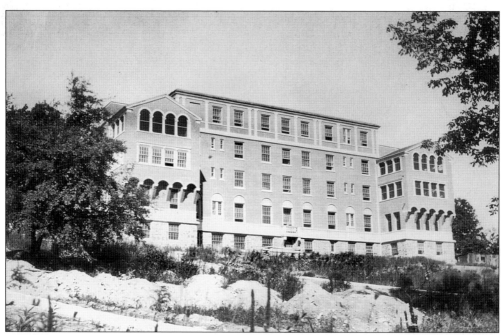

The demand for a city hospital began in 1919 and, in 1920, Roger S. Newell offered as a gift the land on the south slope of Federal Hill. The hospital, with a capacity of 100 beds, was opened in October 1925.

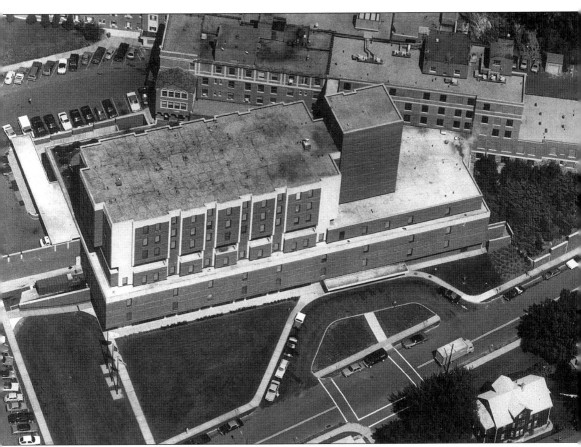

In sharp contrast to the Bristol Hospital in 1925 is the Bristol Hospital in 1979. Shown in this aerial view, the current facility continues to grow to better serve the citizens of Bristol.

As early as 1785, the families of Bristol shared books in some form. This is the Bristol Public Library and Reading Room *c.* 1880.

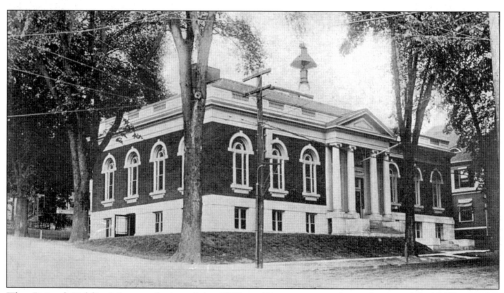

The Bristol Public Library, designed by Wilson Porter, opened on August 14, 1907, on the corner of Main and High Streets, where it stands today, continuing to serve the public.

Seven

ENTERTAINMENT

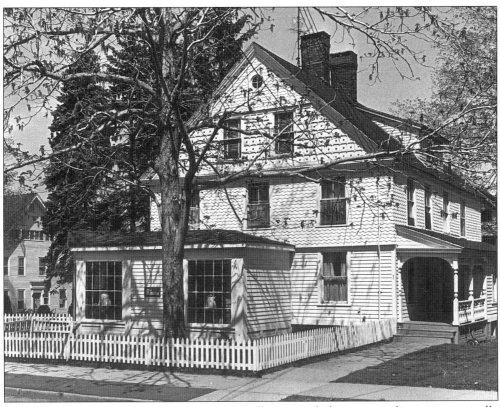

In Colonial America, taverns were important. They gave shelter to out-of-towners, especially on Sundays, when travel was forbidden. They also served the community as a place to meet socially, to enjoy locally made beer and cider, and rum imported from the West Indies. The Able Lewis Tavern, built in 1792, served this purpose for the residents of Federal Hill.

Fishing on the Pequabuck River was at times a favorite form of relaxation.

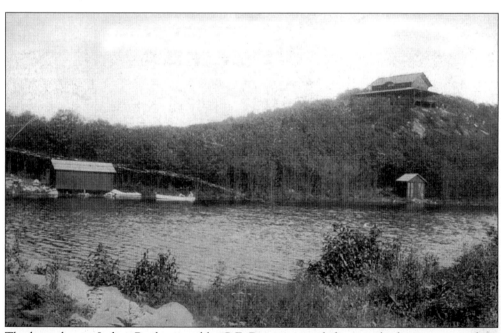

The bungalow at Indian Rock, owned by C.F. Barnes, provided rest and relaxation away from the demands of business.

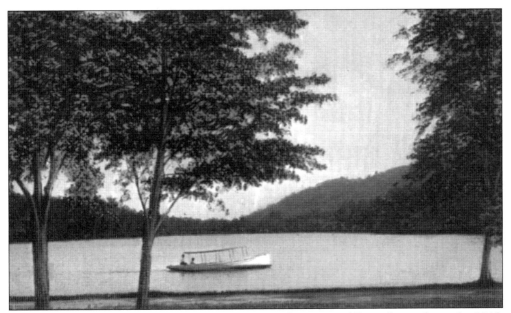

The Industrial Revolution created more free time for many of Bristol's residents. In 1846, Samuel Botsford convinced Gad Norton to allow an electrical demonstration at Lake Compounce. The experiment was a failure. However, it gave Gad Norton an idea. When Norton saw the crowds of people who had gathered to watch, he thought about renting the lake to local people for picnics and boating. He joined with Isaac North in 1851, and the two partners added other attractions, creating an important place for summer entertainment. Lake Compounce is recognized as the oldest amusement park in America.

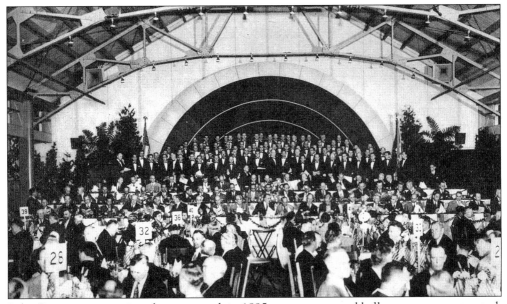

Lake Compounce continued to grow and, in 1895, a restaurant and ballroom were constructed.

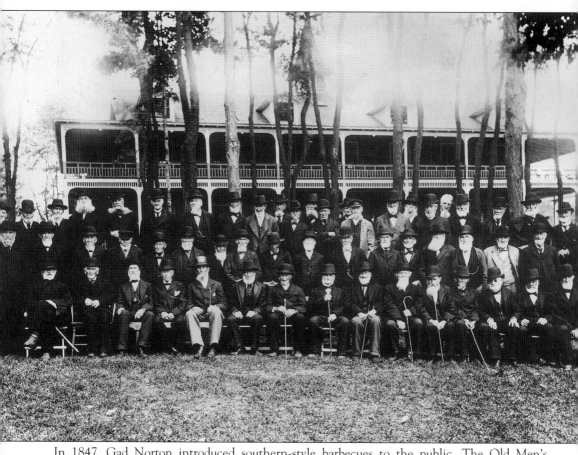

In 1847, Gad Norton introduced southern-style barbecues to the public. The Old Men's Barbecue was one of the most notable gatherings ever held at Lake Compounce. The meeting of the patriarchs of the neighborhood was held in September 1896. No one under the age of 75 was allowed to attend.

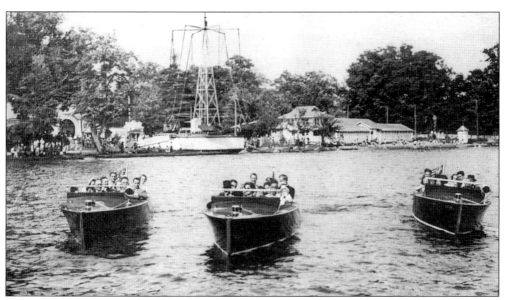

Boating on Lake Compounce provided not only recreation but also respite from the heat of summer days.

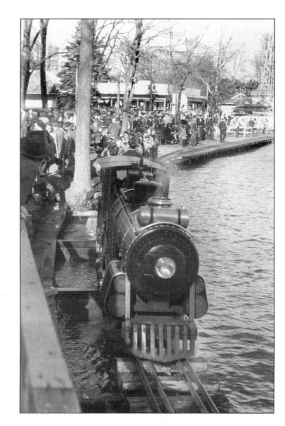

The Gillette Railroad circled the lake, and eager passengers lined up for the ride.

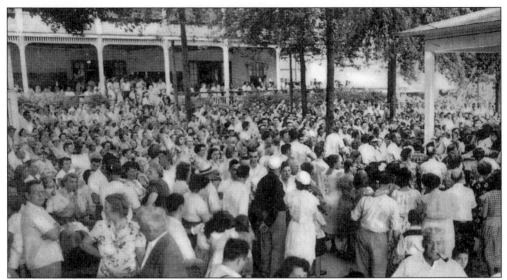

Lake Compounce was the place for the entire family to spend Sunday afternoons. This was a typical crowd on a Sunday at the lake, with people enjoying the outdoor show at the bandstand and children off riding the carousel. Lake Compounce has continued to evolve into a modern amusement park and is still in operation to this day.

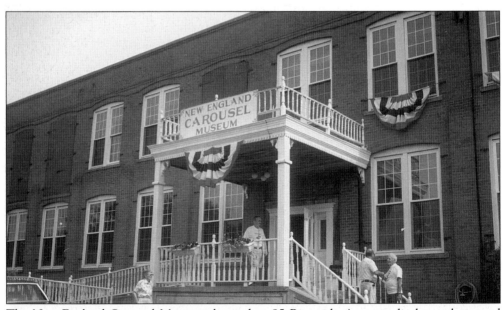

The New England Carousel Museum, located at 95 Riverside Avenue, displays a large and diversified collection of carousel memorabilia. The museum also offers educational programs and activities for children of all ages.

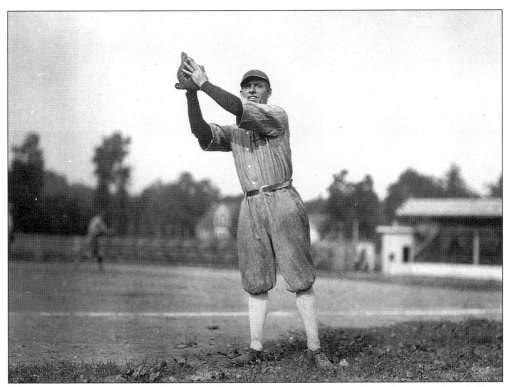

The New Departure Manufacturing Company was instrumental in bringing baseball to Bristol. Here, one of the New Departure Bell Ringers uses his throwing hand to secure a just-caught ball.

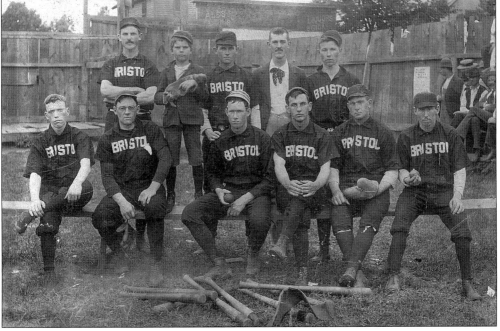

For a time Bristol was in a statewide baseball league. This photograph shows the 1894 team.

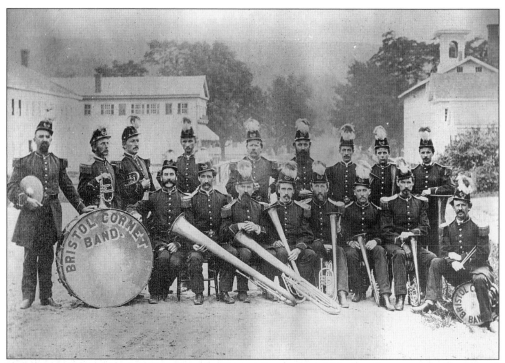

The music of marching bands such as the Bristol Cornet Band has long been enjoyed by Bristol residents. Band members pose for this photograph in front of the S.E. Root Factory *c.* 1870.

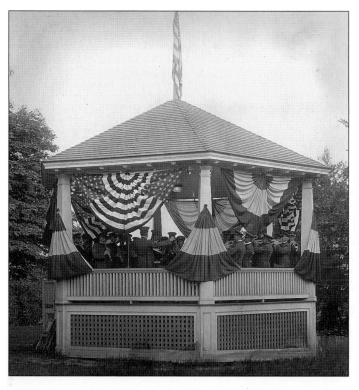

The New Departure Band performs a concert in the Federal Hill Green band shell on Flag Day of 1919.

Golfers enjoy a round of their favorite sport *c*. 1900 at the Clover Hill Golf Course, located on the farm of J.L. Wilcox.

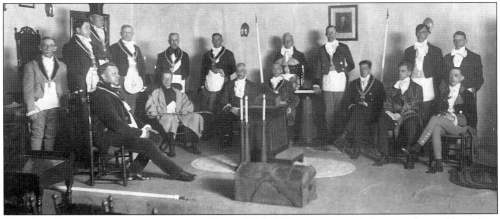

Social groups were an important part of Bristol life 100 years ago. Clubs were formed based on ethnic backgrounds, shared interests, and socioeconomic status. The Lodge of Masons, seen posing in 1912, attracted Bristol's most prominent citizens, such as Edward Ingraham, shown seated, wearing a gray coat and holding a cane.

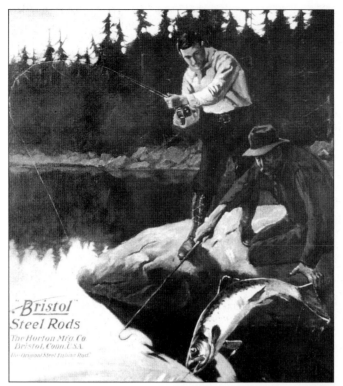

Fishing is a favorite
pastime for many.
For Bristol residents
it could be made
even more enjoyable
by using a locally
manufactured fishing
rod, built by the Horton
Manufacturing Company.

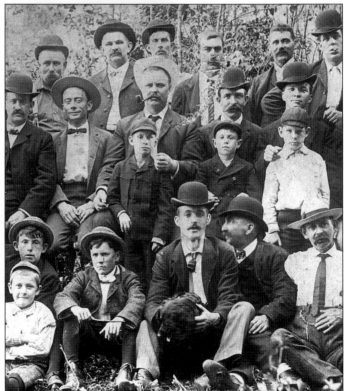

The West Hill Fishing
Club in 1895 was a
popular sporting
organization. In the center
are Dr. George S. Hull,
(with the white hat) and
his son, George W. Hull.

Young people and adults delighted in the lagoon at Rockwell Park and the Children's Playground. The park was donated to the city in 1914 by Albert F. Rockwell; it opened to the public in 1917. It is listed on the National Register of Historic Places for its landscape architecture.

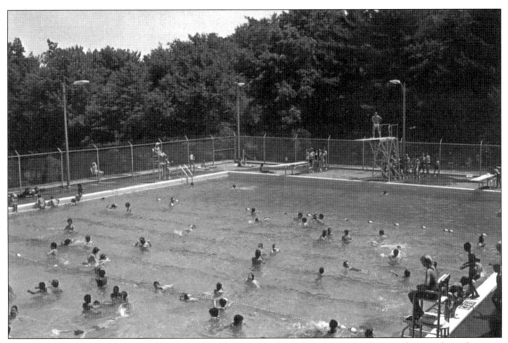

The Page Park pool is the place to take a dip on a hot day. Page Park was donated to the city in 1933 by Dewitt Page.

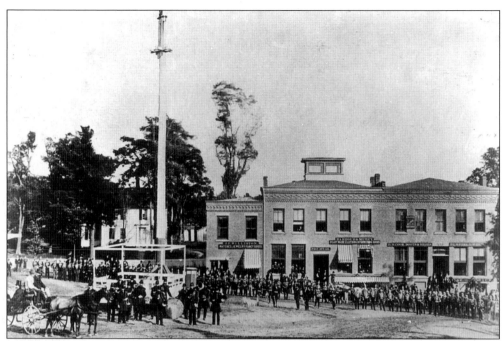

Bristol has always enjoyed a parade. This picture was taken in 1877 in what was called Depot Square.

Bristol held a parade to support U.S. overseas troops during World War I. This group is shown passing by the Gridley House, at the corner of Main and North Main Streets, in 1918.

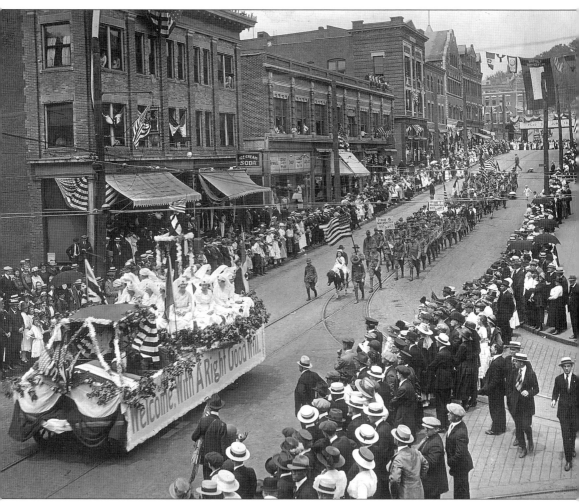

The Flag Day Parade in 1919 shows how Main Street, with its various shops and businesses, looked that year.

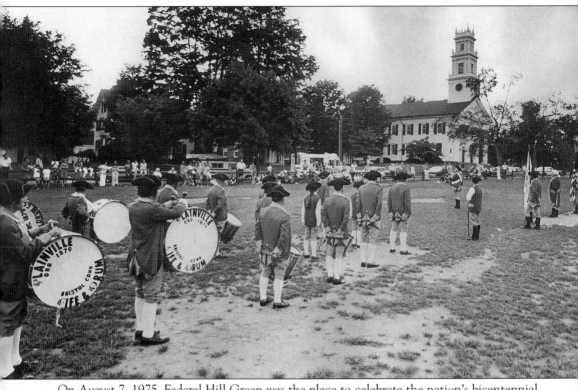

On August 7, 1975, Federal Hill Green was the place to celebrate the nation's bicentennial.

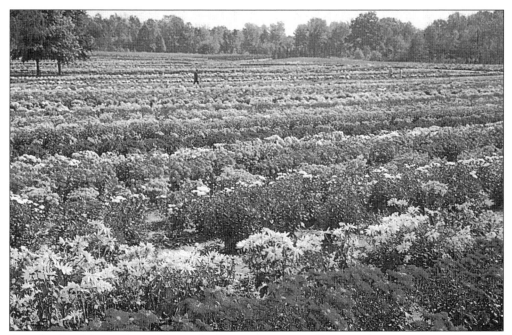

Bristol, the Mum City, delivered chrysanthemums all over the country and around the world. At the height of its production, Bristol grew 75,000 plants between mid-September and mid-October.

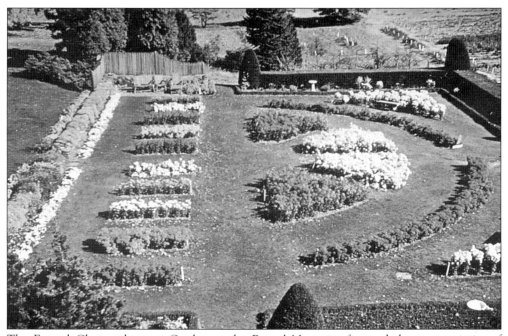

The Formal Chrysanthemum Garden at the Bristol Nurseries featured the new varieties of mums along with the older varieties. The gardens made this scene one of New England's most colorful fall displays.

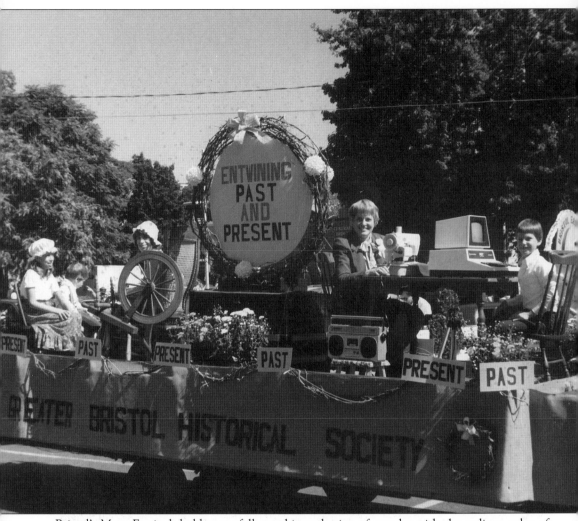

Bristol's Mum Festival, held every fall, combines the joy of parades with the radiant color of chrysanthemums. Bristol continues to celebrate this tradition.

Eight

VIEWS OF BRISTOL

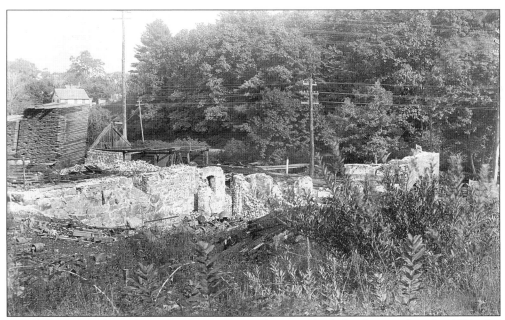

Bristol has gone through many changes since the arrival of the first settlers. In 1880, the remains of older industries, such as the ruins of this factory on Church Street, could be seen around the downtown area. Note the stack of new lumber to the left, awaiting use as the new replaces the old in the city's ever-changing core.

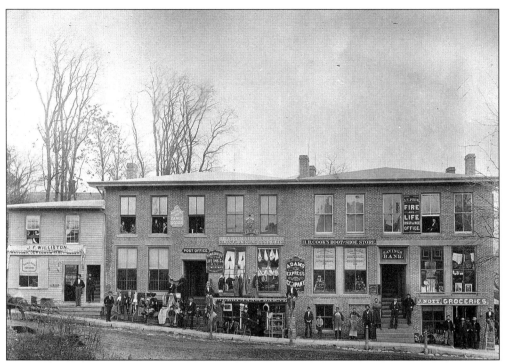

Here is the Nott-Seymour Building, also known as the Brick Block and the Post Office Block, as it looked in 1858. This building, located just south of the railroad crossing on Main Street, was the first brick block constructed in Bristol.

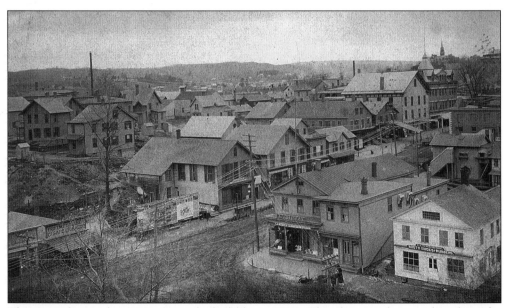

This view shows what Main Street looked like in 1891. The photograph was taken from the smokestack of the American Silver Company. Note the Gridley House at the end of the block.

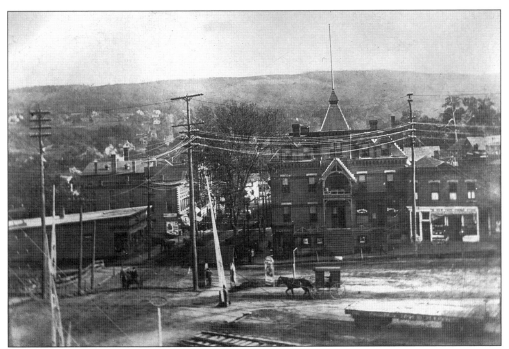

The Gridley House was a beautiful brick hotel built just south of the Main Street-railroad intersection in 1880. This grand structure was moved a short distance to allow for the change in the grade of Main Street when the street was made to pass under the tracks.

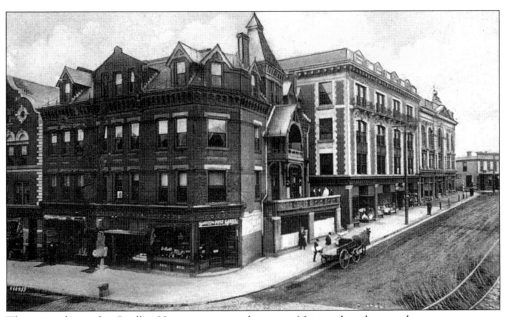

This view shows the Gridley House in its new location. Notice that the wooden structures near the hotel have been removed and replaced with brick commercial buildings.

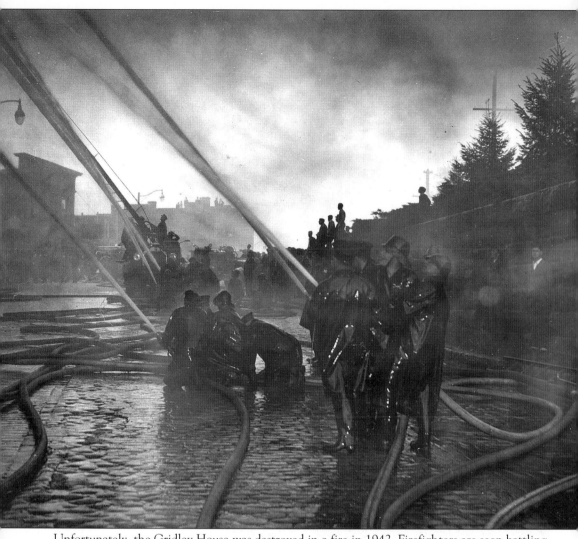

Unfortunately, the Gridley House was destroyed in a fire in 1942. Firefighters are seen battling the blaze.

Employees of the Bristol Press pose *c.* 1900 for a photograph in front of the company, which at the time was located on Riverside Avenue. The *Bristol Press* began as a weekly newspaper. The first issue was published on March 9, 1871.

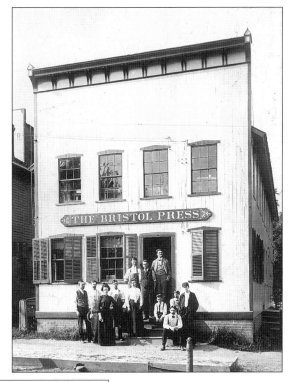

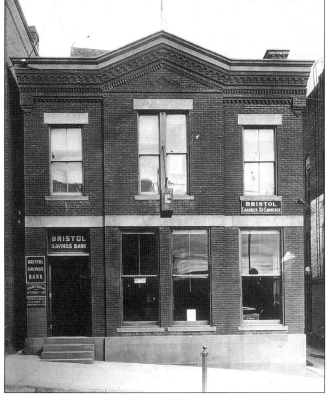

The Bristol Savings Bank was built on Main Street north of the railroad tracks in 1873. The Bristol Chamber of Commerce had its offices on the second floor. The bank remained in this building until 1924, when its new office was built on the corner of Main Street and Riverside Avenue.

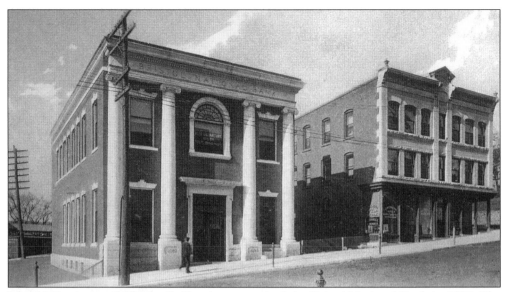

John H. Sessions and Charles S. Treadway organized the Bristol National Bank in 1875. The bank occupied this building in 1877 and remained there until 1922, when it built a new bank on the east side of Main Street, south of the railroad.

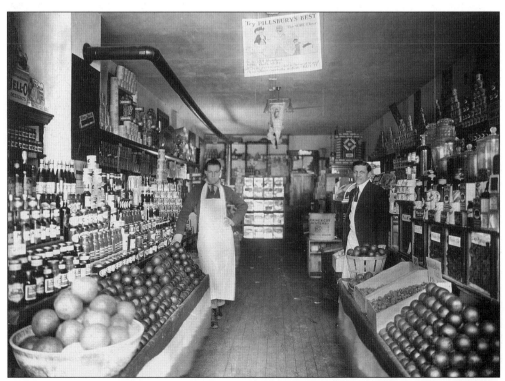

Local businesses were the mainstay of the downtown area. Woodruff's Bakery and Grocery store was located on Main Street.

Eating establishments opened to accommodate the growing downtown work force. Charles Lundgren and an unidentified person stand in front of the Uneeda Lunch Room at the end of World War I.

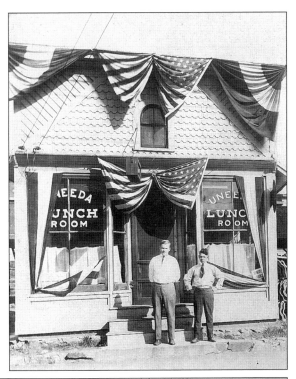

This view shows the corner of Center and North Main Streets, with the Uneeda Lunch Room on the right. The area was later cleared to provide parking for employees of the New Departure Company. Today, the Bristol Fire Department is located on the site.

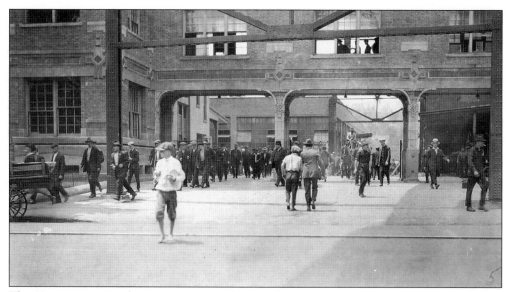

The main entrance to the New Departure plant was located on North Main Street. The workers at the various plants greatly contributed to the expanding downtown area.

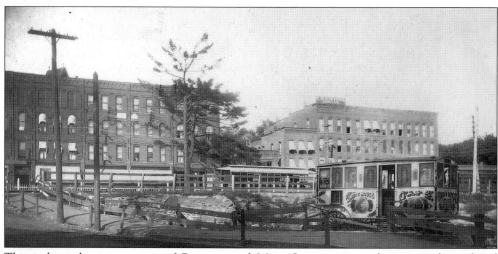

This is how the intersection of Prospect and Main Streets appeared prior to the railroad overpass construction.

This photograph shows the corner of Main and Prospect Streets, with the Bristol Savings Bank on the left and the Episcopal church on the right.

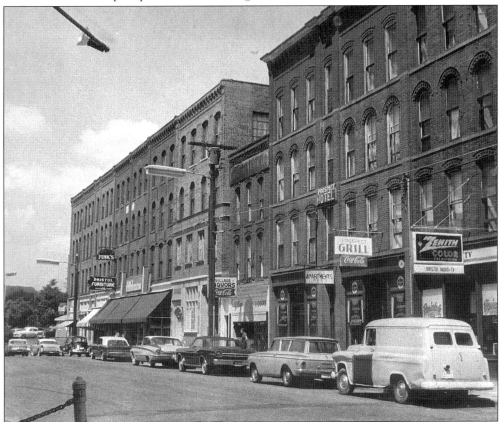

As the downtown area continued to grow, many small businesses began to appear on Prospect Street.

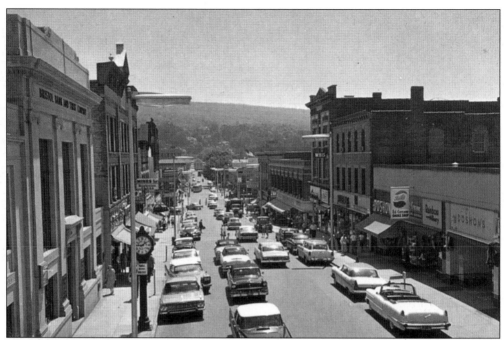

Main Street was the place to shop and bank. The clock in front of the bank has been a familiar sight for years. Notice the variety of stores on the right, all favorites of Bristol shoppers.

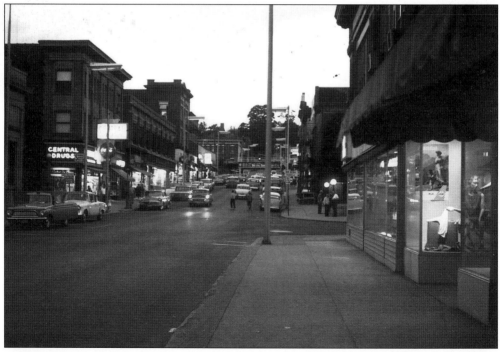

Downtown or uptown, no matter where one lived, Bristol was always a busy place, even at night.

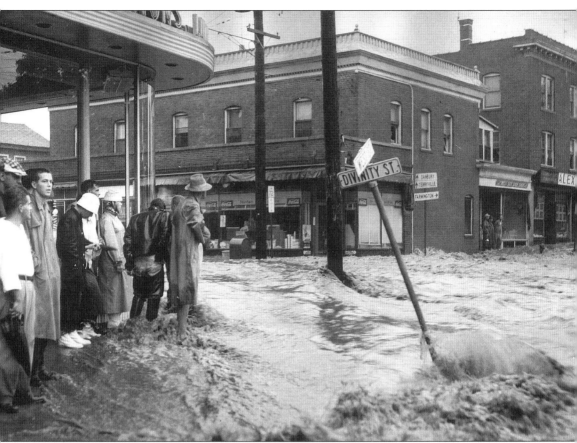

The Pequabuck was one of several rivers in western Connecticut to flood its banks after the torrential rains of August 19, 1955. The flood caused $3.5 million worth of damage to the city. This event created a concern for flood control and was one of the major reasons for downtown redevelopment.

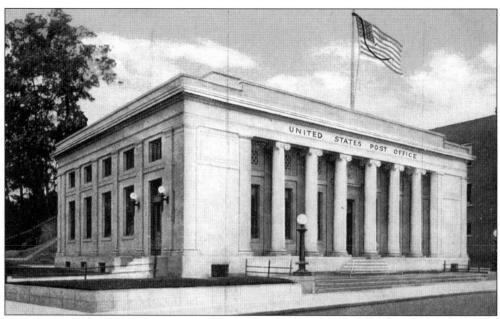

The first post office in Bristol was established in 1812, with Lott Newell as postmaster. The post office was conducted in leased space, often changing location until the government purchased the lot on Main Street and built the first permanent structure in 1913. The post office is considered by many to be the biggest loss of redevelopment.

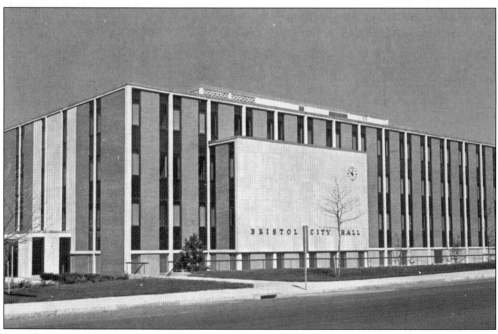

Bristol City Hall is an example of the type of architecture that replaced numerous downtown buildings as part of redevelopment.

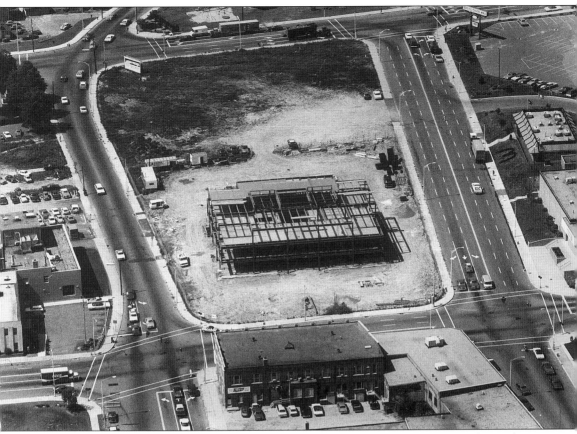

This aerial view of the construction of Barnes Group World Headquarters in 1979 shows the redevelopment area. Notice McDonald's and the Bristol Center Mall on the right. The ever-changing face of downtown Bristol is evident in this photograph.

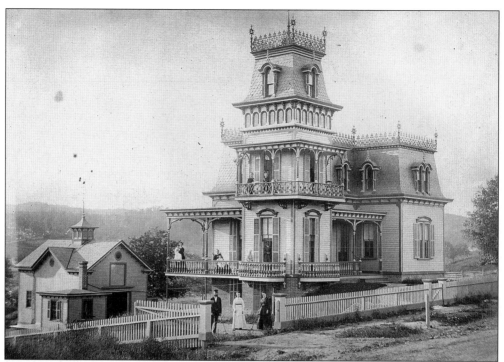

Building began in earnest in the 1870s and 1880s in the Federal Hill area. Inventor and businessman Joel Case designed and built a number of the homes. He lived in each house a short time before selling it and moving on to a new project. Many of the fine old homes built during the late 19th century have been destroyed, such as this house on Summer Street.

The house at 16–18 Spring Street was built by Joel Case. Notice the Case Block on the left.

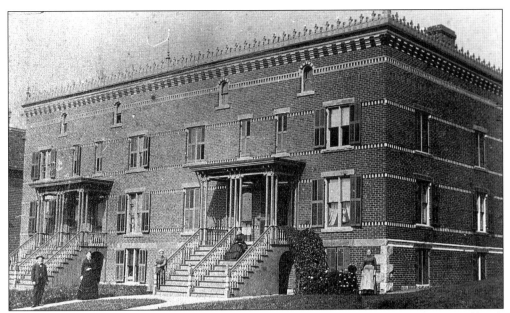

Joel Case constructed the Case Block, at 22–28 Spring Street, in 1881. The pattern of brick detailing, with courses of bright painted headers, and the splendid porches gave the building its ornate character.

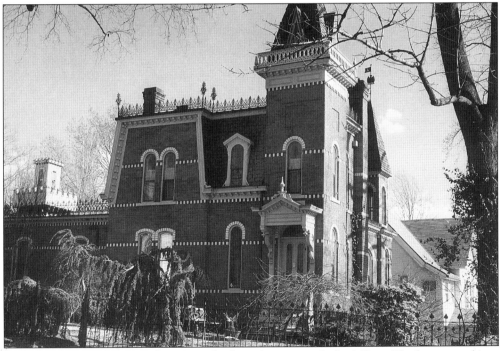

Castle Largo, at 230 Center Street, was built in three stages by Joel Case. The house combines a variety of styles: Italianate windows, towers, brickwork, a Second Empire-derived roof, and elements of Gothic Revival. One of the most unusual houses on Federal Hill, it was considered an oddity at the time of its construction. It has been carefully restored and looks now much as it did in 1880, adding to the flavor and charm of Federal Hill.

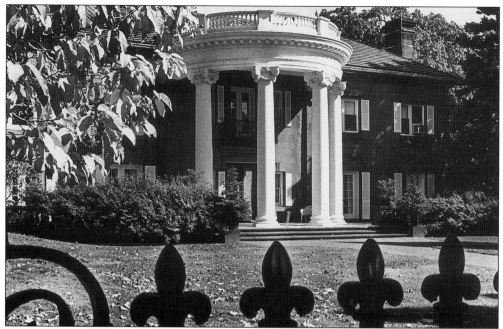

Beleden was constructed over a period of two years by William E. Sessions and was first occupied in 1910. The name Beleden came from the Italian "bel," meaning beautiful, and "eden," the Hebrew word for garden. The house was designed by Boston architect Samuel Brown and was the frontispiece to a large estate that included a sunken formal garden, an English garden, a pool, greenhouses, grape arbors, and vegetable gardens. A staff of 18 was required to maintain the estate.

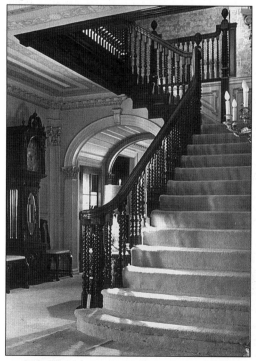

The interior of Beleden is richly detailed with classical elements and the finest materials. The house was advanced for its time, having its own water filtration system, central vacuuming, and telephones in every room. Although some of the surrounding grounds have been lost to subdivision and development, the house has been carefully restored and is a showcase of beauty and elegance.

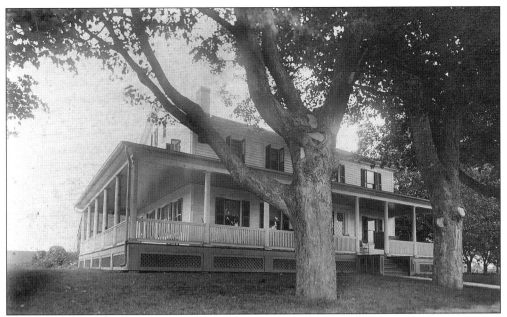

Chippens Hill was also the site of beautiful homes. The Shepard House was built between 1810 and 1820 by Samuel Jones, a well-known farmer and carpenter. For a time after its founding, the Franklin Lodge of the Masonic Order held meetings in the second-floor ballroom of the Shepard House.

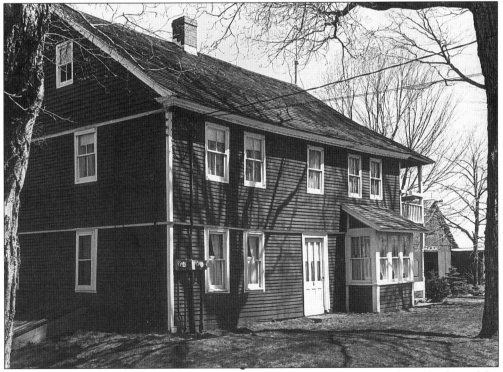

This former residence of Isaac Shelton was typical of the homes built in the early days of the Chippens settlement, c. 1760, on Matthews Street.

Chippens Hill has retained many of the scenic farms that were established by the early settlers. The barn in the background was built by Allen Manchester. The farm was later sold to the Roberts family. During the Mum Festival, the Roberts family graciously opens the property to the public, providing activities for Bristol residents to enjoy.

Chippens Hill was not spared from the changes of the 20th century. The New Departure-Hyatt Bearings plant and administrative building relocated to new facilities on Chippens Hill.

Nine
VIEWS OF FORESTVILLE

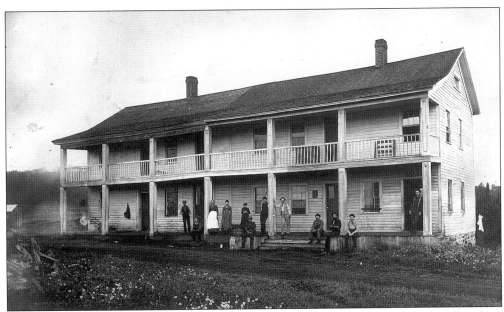

In 1833, J.C. Brown, W.G. Bartholomew, and W. Hills bought the land in Forestville, along with the right to dam the river, and began a clock factory. A bridge was built across what is now Central Street, and highways were opened to the east and south. The company organized under the name of the Forestville Manufacturing Company. Soon, workmen began building their houses in the area and Forestville began to exist as a separate village. Forestville became the largest and most independent of all the separate localities within Bristol. This boardinghouse was located on Church Avenue.

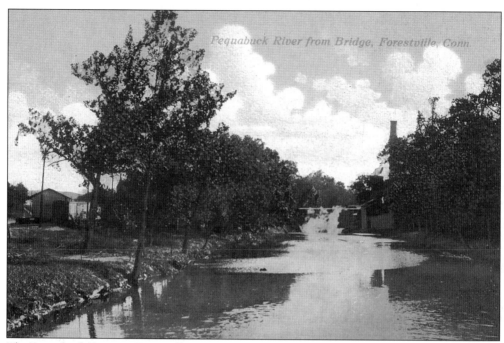

The Pequabuck River in Forestville provided the energy needed for the manufacturing of clocks and added to the growth of the "village."

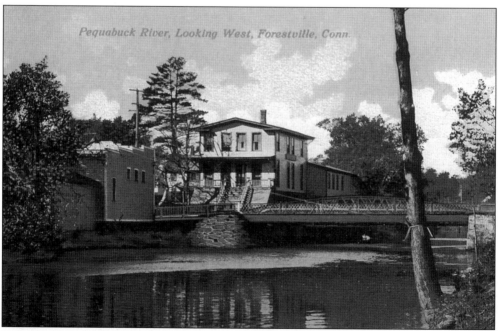

From the Pequabuck River, looking west, one could see the center of Forestville—a sight still enjoyed by many today.

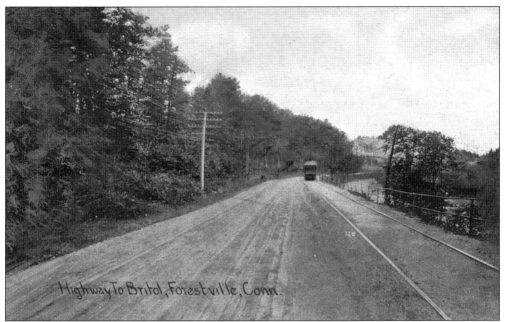

Forestville developed a separate political and ethnic identity from Bristol. The area was heavily populated by the Irish and was mainly Democratic. There was some talk of separate town status in 1870, but when the area was made a separate voting district in 1872, the talk subsided. The residents of Forestville regularly traveled to Bristol along this highway, which followed the Pequabuck River.

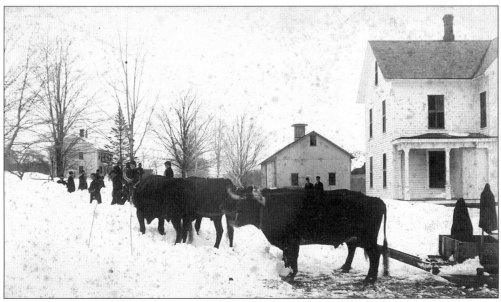

On a wintry day, William Buckley travels with his team of oxen past the corner of Central and Washington Streets.

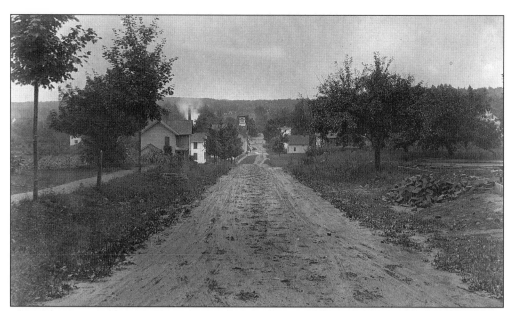

This is a scene of Central Street, looking toward Forestville center from Washington Street in the 1880s. Oxen and horses were still the main means for individual travel and for working the land.

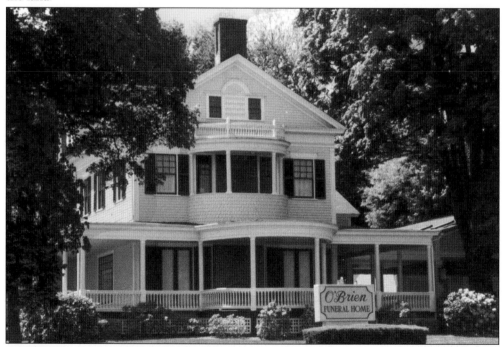

E.N. Welch was the founder of both the E.N. Welch Manufacturing Company and the Bristol Brass and Clock Company and the principal stockholder of the Bristol Manufacturing Company. He had this home built in Forestville as a wedding present for his daughter, Mrs. G.H. Marshall. It was designed to resemble a river showboat. The garages are the original stables, and the house retains all of its charm and elegance thanks to the care of the O'Brien family, who purchased it in 1942.

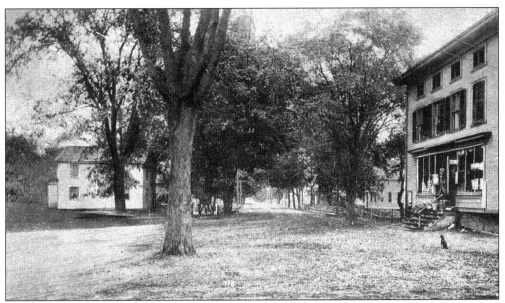

This scene of Main Street in Forestville in the 1880s shows the continued commercial growth that took place, although on a smaller scale than in Bristol. Forestville was gradually becoming a more independent village and soon had its own schoolhouse, post office, fire station, and train station.

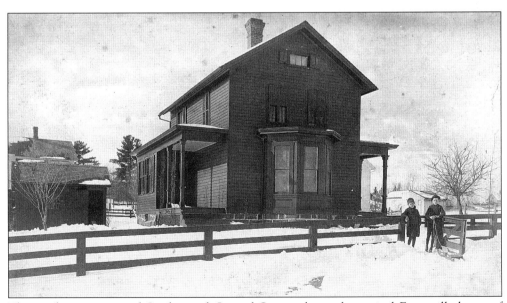

The southwest corner of Garden and Central Streets shows the typical Forestville home of the 1880s. Elijah Manross, the great-great-grandson of Nehemiah Manross, was born and raised on Garden Street. He and his descendants played an important role in building the community of Forestville.

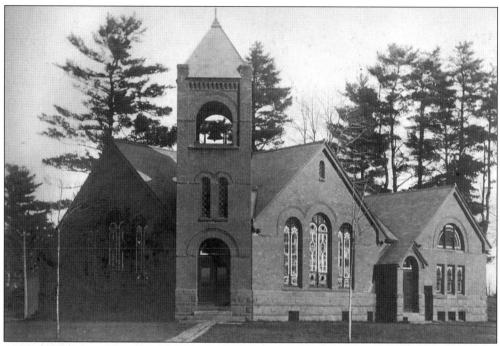

As the village grew, churches were built to accommodate the residents. The Methodist church was organized in 1855.

St. Mathew's Church was completed and dedicated in 1897. The residents of Forestville began to form their own religious, social, and sporting groups, such as the Old Time Forestville Scholars, the Forestville Cornet Band, and the Forestville Athletic Club.

The Forestville Cemetery, once called the East Cemetery, was officially established and deeded to the town in 1853, but burials took place before then. The first recorded burial was that of Washington Atkins, a two-year-old child, in 1831. The cemetery is the burial place of three veterans of the War of 1812—Elisha Manross, Philo Botsford, and Lott Jerome—and 53 veterans of the Civil War, including Newton S. Manross.

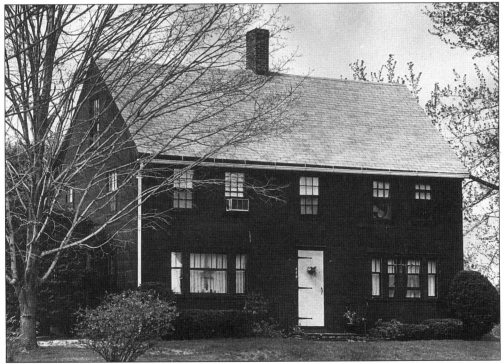

Washington Street was the highway between Plainville and Waterbury, and many of the older homes still exist there. This home, at 449 Washington Street (near Camp Street), is one of the oldest on the street and was probably used as a tavern in the early 1800s.

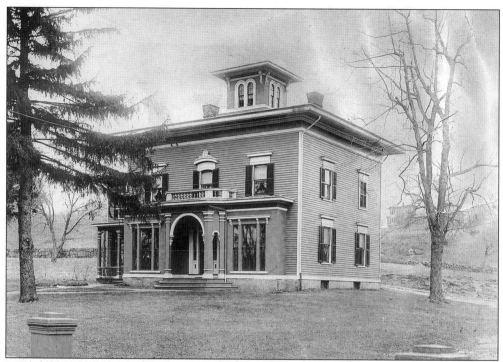

Laport Hubbell was a clock maker and operated a factory on Frederick Street that made marine clocks and self-winding clocks. He purchased the company from Brainbridge Barnes, who was the first inventor in the United States to succeed in perfecting a marine movement clock. Hubbell resided in this house, at 5 Washington Street.

Miles Curtiss built this house on Washington Street in 1828.

This house, at 211 Washington Street, is typical of the homes built in the area. It still retains its style and appeal today.

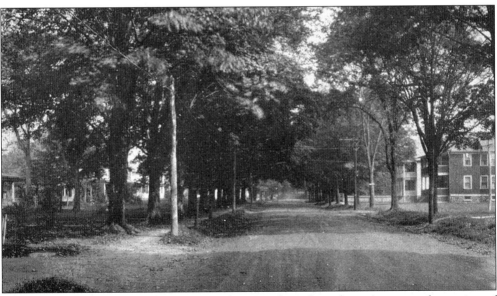

This scene of Washington Street in the early 1900s shows how the area grew, with a variety of single-family and two-family homes. The canopy of trees added to the charm of the street; however, many of these old trees were recently cut down.

The Forestville Boys' Club provided many programs for the youth of the area and was a favorite, familiar site near the center of the village. Although the Boys' Club closed, the building has been carefully restored and has become the home of Ultimate Wireforms Inc.

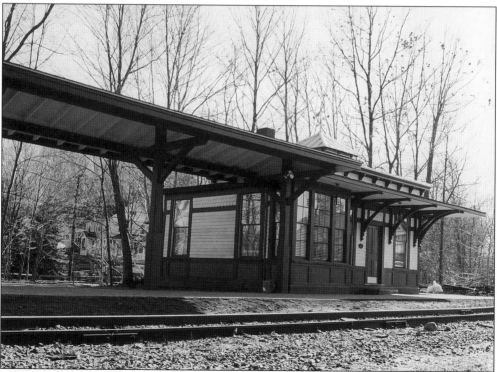

Perhaps the most familiar landmark in Forestville center is the train station, which is on the National Historic Registry. It has been beautifully restored by its current owner, Peter Roberge of Roberge Painting, and is once again a symbol of the pride and uniqueness that is Forestville.